JAPAN STYLE

JAPAN STYLE

Essays by Mitsukuni Yoshida, J. V. Earle, Masaru Katzumie, Jean-Pierre Lehmann Art direction by Ikko Tanaka

SERINDIA PUBLICATIONS

Produced by Kodansha International Ltd.
with the assistance of a grant from the
Commemorative Association for the Japan
World Exposition.

Copyright © 1980 by The Japan Foundation,
Park Building, 3 Kioi-cho, Chiyoda-ku,
Tokyo 102.

Published by Kodansha International Ltd.
2-12-21 Otowa, Bunkyo-ku, Tokyo 112,
in collaboration with The Japan Foundation,
Park Building, 3 Kioi-cho, Chiyoda-ku,
Tokyo 102, and the Victoria and Albert
Museum, London SW7 2RL.

ISBN 0 906026 03 2

Trade edition first published in the
United Kingdom and Europe by
SERINDIA PUBLICATIONS
10 Parkfields, Putney, London SW15 6NH, U.K.

Printed in Japan.
First edition, 1980.

CONTENTS

Japan Style —Yesterday, Today and Tomorrow

Masaru Katzumie

I must admit that when our British friends suggested the title of this exhibition should be "Japan Style", we had certain reservations about accepting the phrase as it stood. Supposing we could climb aboard a time machine and travel back to nineteenth century Japan, we would probably find, it is true, that the words "Japan Style" aptly described the life being lived then; again, if we were to climb aboard the famous Bullet Train and travel from Tokyo (the modern capital) to Kyoto (the former capital, with a proud history going back more than a millennium), I think we would realise that the life of the latter city still had a certain unity and harmony, which justified the use of the same expression.

I know, however, that if I were to speak of modern Kyoto, a city with a population of over one million, as being no more than a cultural relic, I should probably incur the wrath of the inhabitants. Nevertheless, the weight of history and the force of tradition have given the streets of the city an undeniably unified and harmonious atmosphere. Even though Kyoto has yielded to Tokyo the role of political and financial capital, there remains, underlying the complex psychology of her citizens, a certain pride in the fact that, when it comes to traditional life and culture, their city is still at the centre of things.

Everywhere in Japan there may be found old castle-towns, which retain something of the flavour of days gone by (although not in such perfect form as Kyoto itself), and some years ago the Japan National Railways ran a publicity campaign with the English title "Discover Japan" in an effort to get tourists of the younger generation to visit these little Kyotos. As a result, every holiday large charabancs disgorged crowds of young people who strolled around the ancient streets of such towns in brightly coloured T-shirts and jeans. So essential has it become for us to draw attention to the fact that the fine old traditions and cultural

patterns of Japan are being lost or destroyed that we have to make deliberate use of the English word "discover" in appealing to the young people who will shape the future of our country. And yet the "Japanese things" in which our foreign friends show most interest almost all pertain to that fine old tradition. Woodblock prints, *shōji* (translucent sliding paper screens), *noren* (decorative curtains), *monshō* (heraldic crests), *tatami* matting, *bonsai* trees, *kimono*, *kabuki* theatre, *sumō* wrestling—all of them developed in the Edo period (1615–1868), and we have done no more than inherit them in an already perfected state and repeat and perpetuate them without alteration.

Japan in the Edo period occupied a peculiar position in the general history of the world: just when the countries of Europe and America were embracing mercantilism and plunging headlong into the industrial revolution, the Tokugawa government was virtually cutting Japan off from the outside world by a conscious policy of national isolation. Apart from maintaining commercial relations with Chinese and Dutch merchants via the single port of Nagasaki, to which the foreigners were confined, the authorities allowed no external trade of any kind. By way of compensation they pursued a domestic policy of strengthening the feudal system and encouraging cultural unity and in so doing they managed to keep the country at peace for more than 250 years.

At the end of the seventeenth century the city of Edo (the old name for Tokyo) already had a million inhabitants, and it is not often realised that the government was forced to adopt a number of measures to stem the drift of population away from the provinces towards this large city. It is estimated that there were about thirty million people in Japan at the time; on the one hand the government introduced measures to prevent any further increase, and on the other hand it encouraged the stepping up of food production to meet the needs of the existing population. James Clavell's best-selling historical novel *Shogun* performed an eminently useful task in drawing the world's attention to this important and hitherto hidden chapter in Japanese history.

But the new government that overthrew the Tokugawa regime in 1868 (the year of the so-called Meiji Restoration) decided to reverse the existing policy of national isolation and encourage population increase and contacts with the outside world. The radical approach of the Meiji government, which aimed to establish a modern state by introducing science and technology from advanced Western nations, is reflected in the contemporary slogan *bummei kaika* ("civilisation and enlightenment"), while another phrase fashionable at the time, *jōtō hakurai* ("high-class imports"), is a vivid illustration of the susceptibility of ordinary people to the novel goods that were being imported from the industrialised countries of Europe and America. But the traditional life and culture referred to above, which had grown to maturity and refinement over the previous 250 years, were not so powerless nor so lacking in practical value as to be easily swept away by this new tide of "civilisation and enlightenment" and "high-class imports". The result was a kind of dichotomy —a dichotomy by which, for the past hundred years, we have been in a state of

perpetual oscillation between the opposed phenomena of tradition and progress, Japanese and Western.

Such oppositions have of course been experienced in the West as well, but there the choice has been between the maintenance or rejection of traditions based on a continuous and homogeneous historical process. This guarantee of historical continuity does not exist in Japan, and so the opposition between modernism and traditionalism has tended to be equated with two quite different historical experiences, that of the West and that of Japan. The resulting, peculiarly Japanese, brand of dualism has invaded every aspect of our life, from clothes, food and houses to art and culture in general. We make distinctions between Japanese rooms and Western rooms, Japanese clothes and Western clothes, Japanese food and Western food.

We Japanese have grown quite used to this kind of dualism and as a rule we are quite unconscious of these distinctions, but it seems that they can raise problems for foreign visitors to Japan. For example, because of the quite obvious difference between modern Japanese-style painting (*Nihonga*) and modern Japanese Western-style painting (*Yōga*), it has become customary to display the two types in separate rooms when exhibitions are set up. But it was not until some German friends raised the matter that I noticed our failure to make such a distinction in the case of sculpture.

In spite of this kind of inconsistency and vagueness, which may in any case be a specially Japanese trait, it is an undeniable fact that there does exist a dualistic tendency to make distinctions between the Western and the Japanese aspects of our lives. Since the Meiji period (1868–1912) we have been through all manner of trials and errors in our efforts to overcome this kind of dualism and achieve a unified cultural pattern, but so far none of our experiments has been entirely successful. In fact the position we have reached after a century of struggle seems to be more a kind of resourceful eclecticism, which admits the existence of the dualism I have described and makes best use of Japanese or Western things according to time and circumstance. This sensitive realisation and practical acceptance of the situation may be seen as an eloquent expression of the positive outlook of the Japanese people: they turn eclecticism to their advantage and use it as a means of adding variety and enjoyment to their lives.

To give a well-known example, a commuter who wears a convenient Western-style suit at the office during the day relaxes in a Japanese *yukata* (light cotton *kimono*) when he gets home in the evening. In the same way, girls who normally prefer to wear Western-style clothes choose to put on splendid *kimono*s for weddings and other formal occasions. The sight of young women, who up until the day before were in hippy-style clothes, gathering all dressed in formal *kimono*s for a coming-of-age ceremony is a modern spectacle on a par with the traditional folk festivals of old. Before the war, middle-class households preferred to live in one-family houses, which included, as a status symbol, at least one room in Western style complete with piano and sofa. Post-war apartment blocks are, generally

speaking, in Western style, but the planners of such buildings have always to bear in mind the fondness of the people who will live in them for rooms floored in Japanese style with *tatami* straw matting.

To turn to our eating habits, it seems that the heterogeneous nature of modern Japanese food is such that it is not possible to make an analysis in terms of "native" and "foreign". In Tokyo there are countless restaurants, serving dishes from throughout the world, and every one of them seems to be doing good business. One never hears of a restaurant going bankrupt. If an article recommending one of these places appears in a mass-circulation newspaper, you can be sure that it will be packed from then on. These are simple proofs of the fact that the snobbishness of the Japanese people is by no means confined to art and music alone.

Some years ago an able ceramic designer by the name of Masahiro Mori decided he would try to design a "national tableware", but he has since come to realise that this task is far more difficult than he originally expected it to be. In response to the advice and suggestions of various consultants, Mori has continued to add new items to his set of tableware until now there are more than two hundred different pieces, but he has still not finished. He has held exhibitions of work in which he divided the tableware into three groups—breakfast, lunch and dinner. In fact, there are quite a few Japanese who eat a Western-style breakfast, a lunch consisting of Japanese snacks, and an evening meal that is a combination of Japanese and Western food.

Perhaps the most obvious instance of the Japanese tendency to dualism is the Japanese writing system. More than a thousand years ago we imported the ideographic script (called *kanji* in Japanese) from China and from it we developed two separate sets of syllabic symbols called *hiragana* and *katakana*. Nowadays we use all three systems in conjunction, according to context. All three scripts are written vertically and the columns arranged from right to left, but since the Meiji period we have adopted Arabic numerals and Roman script as well, and when these are used it is necessary to make a choice between writing horizontally or vertically. Probably the first attempts at writing pure Japanese horizontally were inspired by the notes taken by Japanese learning English or French or by bank and company ledgers that made use of Arabic numerals. But even when a decision has been made to write Japanese horizontally, there remains another choice—whether to write from right to left or from left to right. Traditionally, when large signs (for example, the framed notices put up at the entrances to Buddhist temples) were written horizontally, they were written from right to left. To begin with, placards and street signs followed the same practice, but inconsistencies occurred when Roman and Japanese script were used together—for instance, in signs giving the names of railway stations—since the Japanese read from right to left and the Roman script from left to right; such inconsistencies often gave rise to argument and debate. It was not until after the last war that we finally decided on a consistent policy of writing from left to right in such situations. This problem even has

a fundamental effect on the binding of books, for whether a magazine or book should open from right to left (Western style) or from left to right depends on whether the writing inside is vertical or horizontal and whether the lines are arranged from right to left or from left to right. Except in publications where illustrations have most importance and there is not much text, it is rare to find the Western style of binding from right to left in use. It is worth noting that even ephemeral, unbound publications of Western origin such as newspapers open in the traditional way, though people do not notice the fact because newspapers are not bound. This can be seen as yet another instance of Japanese dualism.

Japan's great newspapers are read all over the country, and there are several with a circulation of more than five million; consequently their influence on the population is enormous. But although these great newspapers are basically printed vertically, special headlines, passages involving many Arabic numerals and pages giving details of radio and T.V. programmes are written horizontally, while the advertisements are a veritable jungle of Roman and Japanese, vertical and horizontal. I have wondered for a long time why on earth this dualism is allowed. It is partly due, of course, to the positive outlook of the Japanese people, but it is also true that we have behind us a thousand years and more of indigenous culture: the hundred years or so that have elapsed since the Meiji Restoration are nowhere near long enough for us to absorb a civilisation imported from the West. Furthermore, our writing system has one distinct advantage, which should not be overlooked: Japanese script is usually arranged in a grid layout, which takes the uniformly square shape of the Chinese-derived *kanji* as its basic unit, and this layout permits free interchange between vertical and horizontal writing. It is not possible at present to be certain if this will prove to be much of an advantage in the long run, but, for the time being, the acceptance of a mixed writing system has a powerful effect on our modern culture in general.

The *Kojiki* ("Record of Ancient Matters"), which holds a position in Japanese culture analogous to that of the Norse sagas or the Old Testament in the West, describes the creation of the universe in terms of a giant jellyfish. I sometimes wonder whether modern Japan, these four small islands holding a population of more than a hundred million, may not itself be rather like a giant jellyfish, drifting helplessly on the sea of civilisation. Will we ever achieve a culture unified and homogeneous enough to justify us calling it "Japan Style"? All we can do for the moment is to ask our British friends to look at Japan as it is.

Of course we Japanese have not been idle in our efforts to establish a "Japan Style". I remember how at one time we argued furiously among ourselves about the comparative merits of "Japanese Modern" and "Japonica". The debate was sparked off by an article by Rose Slivka in the American magazine *Craft Horizons* (July – August 1956, special issue on Japan, Finland and Italy), in which she expressed the view that "to America . . . has come the old from Japan, the new from Finland and a combination of the old and the new from Italy". I cannot remember who it was who gave Mrs. Slivka her material, but it must be admitted that when we

feel that we are playing to an international audience, we Japanese tend to be too self-conscious about Japan, and as a result when we send material to be displayed at international exhibitions we continue *ad nauseam* to choose objects executed in traditional Japanese techniques, which can easily be recognised as "Japanese" in style. If you ask me, this is essentially an expression of the same attitude as is manifested in the calculated exoticism of souvenir-shop "Japonica". We are still searching for a "Japanese modern style"; although this style is still incomplete and imperfect in many ways, it is my sincere wish that our friends in the international community will acknowledge the validity of our efforts.

I should like to recount in this connection a most interesting anecdote concerning Walter Gropius and Yūsaku Kamekura. Kamekura was more strongly influenced than any other Japanese graphic designer by the Bauhaus movement, and he is famous for the functionalist style of his work; yet when Gropius happened to visit Japan and see a logo designed by Kamekura, he (Gropius) asked if its shape did not derive from some Japanese folk implement. I would not be surprised if Kamekura was a little upset by this totally unexpected enquiry. Be that as it may, the lesson of this story, in my view, is that a logo that Kamekura designed with no consciousness of his Japanese background should appear in Gropius's eyes to have something Japanese about it.

Even the so-called pictograms, whose use I have been striving to encourage since the 1964 Tokyo Olympics and which have recently begun to receive international support, were not conceived with the traditional Japanese heraldic crests (*monshō*) particularly in mind. In fact it was because of my previous experience of the serious language barriers existing in the international community that I resolved to become an advocate of the use of these pictograms. I was motivated by a sincere desire to make it just a little easier for the people who assembled for the 1964 Olympics and 1970 Osaka Expo to overcome the language barriers; if I was conscious of any particular background inspiration at the time, it was not the tradition of the Japanese *monshō* but the Isotypes (International System of Typographic Picture Education) of Otto Neurath in the 1930s or the 1949 United Nations Geneva Protocol on International Communication Signs.

I should like to believe that when we conceive a design in an international context but unconsciously adopt a Japanese approach, the result is something worthy of the description "Japan Style". For the time being, however, we have no choice but to go through an arduous and repetitious process of selection and rejection in our pursuit of this goal. All the same, I should like to conclude by saying how very grateful we are to our British friends for their great kindness in giving us a valuable opportunity to indulge in this rigorous self-analysis.

Why Japan?

J. V. Earle

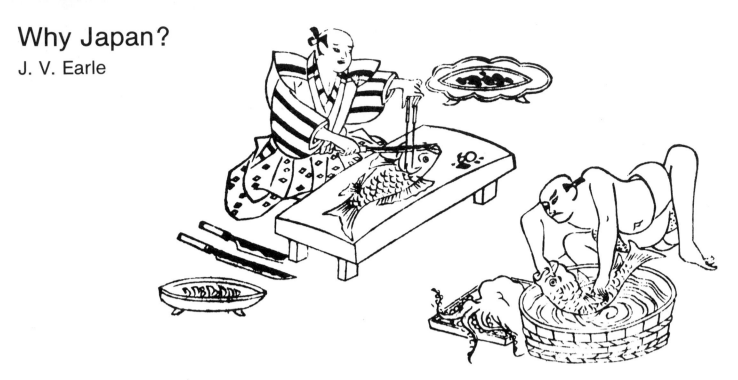

It may well be asked why a museum in London should devote a major exhibition to modern Japanese craft and design and, more particularly, why that exhibition should attempt not only to display modern Japanese artefacts as beautiful objects in their own right but also to convey to the visitor some idea of the visual context in which they are made and used.

The first and probably the most important reason for holding the exhibition at all is that we (and that "we" could mean "we Europeans" as much as "we British") know remarkably little about Japan in spite of its very obvious importance in the modern world. Dr. Lehmann has written, elsewhere in this catalogue, of Western stereotypes of Japanese thought and behaviour, but since this exhibition is, inevitably, devoted primarily to the "look" of modern Japan, it is as well to mention here a widespread *visual* stereotype, which this exhibition aims to dispel, namely that Japan is an undifferentiated megalopolitan hell of jam-packed commuter trains and office buildings, pollution, coin-operated oxygen machines and roof-top golf-courses. In such a stereotype, Japan is seen as somehow vaguely "American", "Westernised" or "international" and entirely devoid of any visual merits or any features that are characteristically Japanese, apart from a few carefully preserved ancient monuments or objects in museum showcases.

In connection with the "Japanese" features whose absence is deplored by subscribers to this stereotype, there are two other widely held misconceptions that should be described. When attempting to analyse the Japanese artistic tradition in a very general way, art historians often speak of two broad stylistic tendencies, the one colourful, decorative, exuberant and inventive, the other monochrome, linear, refined and austere. This is a useful distinction in its way, but it is remarkable how many people with a passing interest in Japanese art imagine one

of the characterisations to be true to the almost complete exclusion of the other. In Britain the most popular representative of the first tendency is the colour woodblock print, while books devoted to the tea ceremony and its architecture, Nō drama, rock gardens and flower arrangement have encouraged belief in the refined, austere stereotype. Neither tendency could survive, of course, in the machine- and commerce-dominated stereotype of modern Japan; such a Japan would be too drab for the life and colour typified by woodblock prints, while traditional austerity and restraint would be drowned in a sea of commercialism. This exhibition aims to demonstrate not only that these two stylistic currents are by no means mutually exclusive, but also that both are very much alive and well in modern Japan.

A second reason for the attempt to convey something of the totality of modern Japanese life (inevitably, this means mostly city life) lies in the opportunities it gives us to make comparisons with our own society. These comparisons are basically of two kinds. It is interesting and instructive on the one hand to see what the Japanese have made of those features of Western material culture that they have borrowed, and on the other hand to identify the aspects of their life today that are purely Japanese in origin. The merchant and artisan classes that came to prominence during the Edo period (1615—1868) developed a distinctive way of life, combining elements from many diverse native traditions, whose visual manifestations were extraordinarily lively and attractive. Since Japan managed to avoid any foreign conquest or occupation during the early stages of contact with Western industrial nations, a surprisingly large number of the characteristic features of this merchant society have survived to the present day. Modern Japan, in fact, is a unique example of the way in which a sophisticated traditional urban culture has adopted Western methods to take on and outstrip the West in terms of trade, industry and the like and yet, to a remarkable degree, has retained its distinctive character. As such, it is in some ways an "alternative" late twentieth century culture. By studying it, we in the West may well discover new and refreshing ways of making and using everyday objects and solving some of the problems that seem increasingly to beset most industrialised nations.

On my first visit to Japan some years ago, since I work in a museum and specialise in traditional Japanese art, I was naturally very keen to see as much as I could in my limited time of Japan's artistic heritage—the temples of Kyoto with their sculptures and gardens, the narrative scrolls of the Kamakura period, the ink paintings of the Muromachi period, the decorative screens of the Momoyama, and the finest possible examples of all the great craft traditions. The longer I stayed there, however, the more I found that my attention was taken up just as much by the beauty of those aspects of Japan's past that survive, albeit often in somewhat altered form, in modern daily life. For example, like every visitor to Japan I was especially struck by the marked attention to visual appearance with which food is served in every Japanese restaurant with any pretensions to quality. The wide range of bowls, boxes, cups, plates and dishes made from many different materials and decorated in many different styles and yet carefully selected to present a

harmonious whole, and the meticulous preparation and presentation of the food itself can make eating in Japan as much an aesthetic as a gastronomic experience. Again, even the most unobservant visitor to Japan cannot fail to notice the widespread survival of traditional techniques and concepts of interior design. Although such a visitor, assuming him to be on a business trip, will stay in a hotel in (almost) pure Western style, the very first time he is entertained (as he surely will be) he will very likely find himself in a restaurant floored with *tatami* straw matting and with sliding paper screens instead of doors and perhaps featuring a *tokonoma* alcove. These two instances of the survival of traditional elements are rather superficial, but in fact most private houses and a great many apartment blocks have Japanese-style rooms, and although the notion that the Japanese like to make the most everyday things beautiful is a cliché, it is nevertheless a cliché with a firm foundation in fact. In the presentation of food, this fact takes its most striking and immediate form.

I mentioned above that some Japanese ways of doing things might suggest solutions to contemporary problems. The plain and almost furnitureless *tatami* and *tokonoma* style of interior design was largely due to the ascetic, spartan tastes of the warrior classes, and although its combination of beauty and convenience has been a great influence on modern architecture, the possibilities that it offers for sparing use of dwindling natural resources have, it seems, not yet been fully exploited. The traditional manner of serving food described above provides similar possibilities for making a pleasure of frugality.

When the visitor ventures out into the shopping streets of Tokyo, he is certain to be struck by the overwhelming bombardment of graphic material that greets his eye wherever he looks. Styles and scripts are many, from elegantly calligraphic characters on wooden notice-boards in temples, which may turn out to mean "No Smoking", to amusing transmogrifications of English, chosen more for *chic* than for literal meaning, if any. The latter are added to practically every commercial advertisement: AT SPRING PLACE; *fashion joyful*; *interior wide space*; and, in large letters atop a department store, MY CITY. Bold use of the Japanese scripts was an important feature of Edo culture, but the wider range of scripts available today (three indigenous systems plus every possible style of Roman script and Arabic numerals) together with the techniques of colour-printing have spurred the modern Japanese on to even greater inventiveness and originality. Although we in the West have to make do with a smaller number of symbols, there is no reason why we should not learn more than we have done to date from the extravagant vitality of modern Japanese graphics.

When we look at Japanese industrial products that are truly "international" in style (electrical goods, cameras, cars, motorcycles and the like), it may seem difficult to account for their excellence in terms of the lasting influence of traditional concepts. However, even if we leave aside such factors as social organisation and attitudes to work, which are beyond the scope of this essay, there are in fact a number of tendencies in traditional design that continue to influence the ap-

pearance of modern, factory-produced goods. Of these tendencies, the most prominent is perhaps the decorative use of functional attributes. Utilitarian objects that are "decorated" in the normal sense of the word (that is to say, the decoration itself makes no contribution to the object's function) abound in Japan and are well represented in Western collections, but we are perhaps not quite so familiar with those objects whose beauty lies in their functional simplicity. The *tatami* straw matting mentioned above and the sliding translucent paper screens (*shōji*) that do the job of windows are examples in the sphere of architecture and interior design. In fact *tatami* (which measure six feet by three feet) were originally used as beds, but the beauty of the patterns made by their black tape edgings when two or more were combined led, eventually, to rooms being entirely floored in *tatami*, a practice that combines great comfort with considerable aesthetic appeal. Two instances of this decorative exploitation of materials, the paper lampshade (derived from the traditional lantern) and the bamboo blind (which was already in use in Japan during the twelfth century), now enjoy widespread popularity in the West; other examples in the exhibition include knives and chopping boards, craftsmen's tools and *geta* (wooden clogs), and the same principle can be seen at work in a great many of the craft items displayed.

There are two features of traditional architecture that testify to the fact that this use of functionalism is by no means always something inevitable, unintentional or unselfconscious. In the framework of a building, the horizontal bracing member called *nageshi* is often far larger that its practical purpose alone would justify and is designed to look like a solid beam when in reality it is made up of planks. The *nageshi* is almost always exposed to view on both sides of the wall and, in fact, while appearing functional, is often included in a building merely for the aesthetic value of the patterns it creates by its intersections with columns and corners. Similarly, in the construction of roofs, elaborate precautions are often taken, in designing the ends of the eaves, to make the roof as a whole appear thicker or thinner than it actually is. Sometimes extra roofing material is added at the edge, sometimes non-functional rafters are put in to hide the real ones. This ability to make use of or tinker with functional elements continues to be of great value in the design of industrial products, for example in deciding the size and distribution of knobs, buttons and switches in the controls of a pocket calculator or amplifier, or in emphasising or playing down the structural members in the construction of a chair, camera or motorcycle.

The pursuit of adaptability and convenience is another traditional tendency that appears to fit in very well with the practice of industrial design. Adaptability is a key concept in traditional domestic architecture: rooms do not have specific functions as they do in the West and they may be separated off or combined simply by inserting or removing sliding screens. Other traditional domestic articles, for example the light *futon* (quilt), which is laid out at night for sleeping and put away during the day, seem to have come into being in response to a liking for objects that are uncluttering and easy to use. Perhaps it is not too far-fetched to see in the *yatate* (ink

and brush in a portable case) the same principle as inspires the design of a radio, calculator and clock as a single unit which fits easily into the pocket or, to take a recent and already celebrated example, the combined traditional abacus (*soroban*) and modern calculator.

Closely related to this penchant for functional simplicity and adaptability is the traditional respect for the inherent beauty of materials. Although it is a far cry from the glazes of tea-ceremony pottery, the brilliant clarity of Japanese porcelain, the grain in the wood of house floors, walls and ceilings or the subtle textures of lacquer to the modern uses of glass, metal and plastic, the Japanese preference for beautifying the surface of an object not by decorating it but by bringing out its natural qualities can be and has been applied successfully to industrial products.

Some visitors to Japan (and to this exhibition) will perhaps be struck not so much by the excellence of industrial design (which is already well known abroad) as by the vitality of the world of the crafts. The styles and schools are many, the polemics are fiercely argued, and craft objects, at every level of quality, are far more widely available than they are in Britain. The example of ceramics vividly illustrates the range: there are potters perpetuating the style of the old tea-ceremony kilns, with varying degrees of departure from classical types; there are members of the *mingei* (folkcraft) movement, of whom the most famous was Shōji Hamada, as well as a few remaining practitioners of crafts in the popular tradition; there are experimenters with Chinese styles and techniques, designer craftsmen attempting to devise international styles combining Japanese and foreign shapes, and avant-garde artist-potters producing everything from vessels loosely based on traditional types to abstract, modernistic ceramic sculptures. The differing levels of quality, from individually crafted masterpieces to mass-produced utensils are, for the uninitiated outsider, bafflingly difficult to disentangle, and the range of materials used is, by comparison with the West, very wide. Although there are cases of considerable hardship—largely a part of the past now—especially in certain purely traditional fields, most craftsmen manage to make a living, helped by associations that hold annual exhibitions and enterprising private craft and department store galleries. Some eventually attain government recognition and receive titles such as "Living National Treasure". It is hoped that the present exhibition, by giving some idea of the breadth and vitality of this side of modern Japanese culture, will provide British craftsmen with ideas, challenges and inspiration.

I have attempted above to give some examples of the survival of traditional ideas of design and to illustrate the ways in which these ideas have been adapted to the demands of modern industrialised society. Japan is not alone in having experienced these processes of survival and adaptation, but she is, to date, the only fully industrialised non-Western nation. This exhibition, by illustrating some of the uses that Japan has made of her splendid and distinctive traditions, may perhaps encourage Western designers and craftsmen to turn to Japan as a source of new ideas and as a yardstick against which to measure the successes and shortcomings of the industrialised West.

Japanese Aesthetic Ideals

Mitsukuni Yoshida

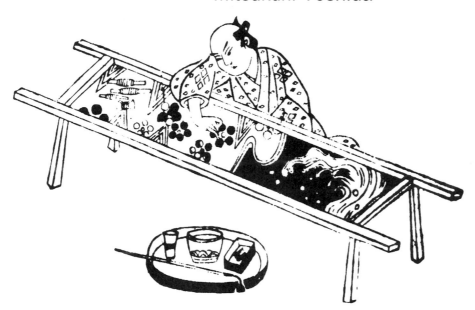

The Earl of Elgin's Mission, which visited Japan in 1858 to negotiate and sign a Treaty of Peace, Friendship and Commerce with Britain, was escorted by a flagship commanded by Captain Sherard Osborn, C.B., and in 1861, after he had completed his tour of duty and returned home, Osborn published a short work with the title *Japanese Fragments* in which he reproduced six landscapes by the famous print artist Andō Hiroshige. Osborn clearly had a high opinion of the print artists of Japan, of whose work he wrote: "these native illustrations, procured in the city of Yedo [modern Tokyo] itself . . . will bring before us in vivid relief the scenery, the towns and villages, the highways and byways of that strange land—the costumes, tastes, and, I might almost say, the feelings of the people—so skilful are Japanese artists in the Hogarth-like talent of transferring to their sketches the characteristics of passing scenes"; and in a comment on one of the prints he reproduces he refers to the artist as "our embryo Turner". For Osborn, the products of the Japanese artisan were filled with refinement and delicacy of feeling: even when gold and silver are liberally used, he says, the effect is not "monstrous, heavy [or] overladen with ornament", but he goes on to imply that the Japanese seemed to him to have taken a conscious decision to avoid investing their artistic productions with anything approaching greatness or grandeur.

The Japanese section of the Great International Exhibition held in London in 1862 (the first occasion of its kind at which Japanese arts and crafts were displayed) was made up of objects collected by Sir Rutherford Alcock, at that time her Majesty's Minister at Edo (Tokyo). Soon after his arrival in Japan, Alcock came to realise that Japanese aesthetic expression and artistic methods were founded on principles quite different from those that prevailed in Europe, and on his return home he made his experiences and observations the basis for a book called *Art*

17

and Art Industries in Japan, published in 1878, in which he made a comparison between the arts and crafts of Europe since classical times and the products of the widely differing aesthetic system of Japan. In his view Japanese arts and crafts, even cheap goods on sale in ordinary shops, were given their special character by perfection of workmanship, variety of form, novelty of design, beauty and grace.

In its constant search for variety of form, Japanese design had developed its own peculiar form of symmetry, which did not depend, as in Europe, on precise geometrical values. For example, the Japanese preferred to use a diagonal, rather than a centrally placed horizontal or vertical line when dividing a rectangle symmetrically. In other cases, they would seek to achieve a balance based on inner meaning rather than shape: in a pair of folding screens, the left-hand screen might represent autumn by a maple tree and the right-hand screen, spring, by a cherry tree. To Japanese eyes, such a composition seems symmetrical and well balanced, in spite of the fact that cherry trees and maples are not at all symmetrical as shapes. Alcock also discovered that the technique of perspective was known in Japan as well as in Europe, and he speculated that it had been brought there around the sixteenth century as a result of missionary influence, either directly by the Jesuits who visited Japan at the time or indirectly by way of China. Modern scholarship has confirmed the correctness of Alcock's surmise; perspective is nowadays generally held to have been introduced from China.

Alcock also devotes some space to an account of the pottery, enamels, ivory, wood-carving and lacquerware of Japan and examines the characteristically Japanese aesthetic consciousness common to work in all these different media. He asserts that "the pictorial side of art is in a comparatively undeveloped state among the Japanese", but he goes on to say that "power of expression, combined with simplicity of treatment, is a characteristic of Japanese Art". Elsewhere he observes that there is inherent in this expressive power an "intense sympathy with Nature", and in spite of his statement about "the pictorial side of Art", he admits that the Japanese "have great dormant pictorial powers".

The Japanese seemed to him, both in major works of art and in those of lesser importance, to have sought to develop their modes of expression to a state of "mechanical perfection", and other qualities of the work of the Japanese craftsman that he noted included a ceaseless and passionate devotion to variety and to natural beauty. In his view, this love of nature's variety took a form in Japanese art quite unlike that which had characterised the art of Europe since classical times. In the Western tradition, artistic creation sprang from the mind and consisted in the production of works possessing a physical, plastic beauty, while Japanese artistic creativity had been channelled in very different ways. Art objects in Japan, he said, were made with a certain emotional quality about them, which brought enjoyment to the lives of ordinary people and evoked in them a sympathetic response to the beauties of nature.

The "Japonisme" which was fashionable in Europe at the time he wrote came in for some harsh criticism from Alcock. He felt that any attempt to copy Japanese

artefacts, which were based on special non-European aesthetic considerations, was doomed to failure. What was worse, at a time when Japan was undergoing rapid industrialisation, "English taste was killing Japanese Art", and Alcock foresaw that the current decline in quality of Japanese goods would be a serious problem in the future. This was regrettable, because Japanese arts and crafts, in spite of the very individual position that they held in world culture, had a certain universality about them, which was attributable to the profoundly human standpoint from which they were made. There is much that we can still agree with in Sir Rutherford Alcock's observations on the arts and crafts of Japan, even though he set them down in writing more than a century ago. In particular, the Japanese people's distinctive sense of symmetry and pursuit of perfection in workmanship, both of which he noticed, even today form an important part of the mental attitudes that dominate all of modern Japan's industries.

Naturally Alcock was fully aware that Japan's culture had come into being under strong Chinese influence. He believed, however, that this influence had come to an end some five hundred years before, after which Japan had begun to pursue an independent line of development. In actual fact Chinese influences had been even stronger during those five centuries. If we take the case of colour, for example, we find that even today the "five colours" of traditional Chinese origin—blue, red, yellow, white and black—are held in high regard. In China these five colours corresponded to the "five elements" of wood, fire, earth, metal and water, which were traditionally believed to be the constituents of the physical world. In Japan, as well, chromatic culture developed on the basis of these five hues. In time, the Japanese discovered the beauty of the intermediate shades that lie between the five colours; they arrived, too, at an understanding of the aesthetic value of the harmonious mixture that results when they are combined with one another. This high regard for colour harmony made an important contribution to the emergence of a feeling for elegance and grace. For the most part it was the ladies of the Heian period (794—1185) court who were the first to discover and develop an appreciation of the beauty of these blended colours, but they soon came to influence the aesthetic attitudes of the male court aristocracy. As a result, even the Japanese warriors' suits of armour were constructed with gorgeously coloured silk threads and leather. At first it was the culture of the Heian court that was most strongly characterised by this feeling for elegance and grace, but in time the courtiers' example led to the widespread diffusion throughout Japanese society of a sensitivity to those qualities.

The motifs used to express this feeling for elegance were always drawn from the natural world, especially the plant kingdom. The climate of Japan is characterised by clear seasonal variations, and because of its never-ending changes nature is seen by the Japanese not as an immutable constant but as a perpetual process of transformation. For this reason, when they speak of the beauty of nature, they are not praising the beauty of its permanence; its aesthetic quality is considered to lie in the fact that its face is forever changing as the seasons go by.

As Alcock implied, the Japanese depiction of this ever-changing natural world is dominated by a pictorial quality, a quality that has sometimes been given the name "graphism". But this "graphism" is in no way a form of realism. In Europe, as well, there are many designs in the applied arts that have a pictorial quality. One example is the tapestries that decorated European courts, but since these tapestries always depict some biblical story, classical myth or mediaeval romance, they are strongly realistic in feeling. Japanese designs, by contrast, are characterized above all by their symbolic qualities. A design incorporating irises growing in profusion by a flowing river immediately conjures up in the Japanese mind the gentle world of the court aristocracy of the Heian period, and the juxtaposition of pines and a single *koto* (Japanese harp) evokes similar mental associations. The romances and the lyrics of the eleventh and twelfth centuries were well known among the Japanese educated classes, just as the mediaeval romances and poems were in Europe. A scene from such a story allowed Japanese viewers to place themselves in the situation implied by the design and indulge freely in pleasant fantasies undistracted by any realistic qualities of the picture. It sometimes seems that such pictures are solely concerned with the external beauty of nature, but even a design that seems to be nothing more than an abstract pattern based on elements drawn from the natural world often holds concealed within itself subtle suggestions of some fable or lyric verse.

Japanese artists made skilful use of this graphic symbolism as a means by which to instil a feeling of human life into scenes taken from nature. But, paradoxically, in achieving this effect, they often try to do without human artifice, relying as much as possible on the latent strength of nature herself, as Alcock and Osborn and other early observers of Japan realised. The pre-industrial crafts make extensive use of natural substances, and the Japanese craftsman in conceiving and executing a product gives full consideration to the special properties of his materials, on which he relies for much of his artistic effect.

An example of this is the use of bamboo, which spread from South-East Asia to China and Japan. The tough and flexible qualities of this material are well known; in China the sight of a flourishing and vigorous grove of bamboo inspired the development of a philosophical attitude that stresses the importance of the individual and makes its aim the internal cultivation and perfection of the self. Such ideas have been influential in Japan as well. Another extraordinary characteristic of bamboo—the fact that a young bamboo plant can grow as much as one metre in a single night—has given the plant mysterious, almost magical associations.

Because of its many and varied properties, bamboo has been put to a number of different uses. Sometimes its quality of flexibility is utilised, at other times it is used in situations where its mysterious properties and its legendary associations are stressed. For example, in that famous indoor cultural activity, the tea ceremony, many articles made from bamboo are used, and the mystery associated with the material makes a definite contribution to the inner meaning of the proceedings. It was in the tea ceremony that bamboo flower holders, either in basket

or cylindrical form, were first used. The latter are often no more than a simple chopped-off piece of stalk. Such simplicity, as Alcock discovered more than a century ago, is an important element of Japanese design. The concentration of perfect workmanship in a simple object is a design principle that has influenced many Japanese craftsmen and become on occasion something of an article of faith. However, simplicity cannot be successful unless it is supported by perfection of craftsmanship; complexity, on the other hand, has on occasion served in attempts to cover up imperfection.

This love of simplicity is closely connected with the idea of modularity, by which a desired shape is achieved by the combination of simpler unit forms. As everyone knows, the tea ceremony is conducted within the confined space of a teahouse (*chashitsu*). But since the size and shape of this space is regulated by the use of *tatami* mats of fixed size for flooring, people find it convenient to use the module afforded by the *tatami* as a guide by which to systematise their physical actions. Furthermore, the size and positioning of every tea utensil is decided after due consideration of the available space, which is itself, of course, fixed by the *tatami* module. It is natural for human beings, surrounded in this way by standardised space and standardised objects, to standardise their own movements.

This tendency to arrange objects in a standardised way in narrow spaces explains the Japanese liking for compactness, in the sense both of many elements skilfully arranged in a limited space and of sparseness, the lack of anything extraneous. In the *chashitsu*, a simple human activity involving fire and water is dramatised by being compressed into a very confined area. In fact, it is not only the drinking of tea that is dramatised in a full tea ceremony, for a complete ceremony involves a formal meal accompanied by *saké* (rice wine).

The love of compactness has even had an effect on literature. The short poetic form known as the *haiku*, which consists of a mere seventeen syllables, has been in existence for five hundred years, and yet even today *haiku* poets and *haiku* clubs can be found in large numbers in every corner of Japan. Another poetic form, the *waka*, made up of thirty-one syllables, dates back more than twelve hundred years, but there are still a surprisingly large number of people who write *waka* and, as with *haiku*, there are specialist groups. More surprising still, most of these poets are amateurs, devoting themselves to the task of achieving a rich expression of the human condition and the beauties of nature within the limited confines of concise poetic forms. The Japanese admire this kind of concision of form and compactness of meaning because they feel that, like simplicity, it derives its aesthetic merit from the fact that it cannot be fully achieved without perfect execution. The reader should take special note of the extensive popularity of these old poetic forms among ordinary people, for it is a proof of the continuing and widespread survival of a feeling for beauty among the Japanese population at large. As Alcock and his contemporaries found, Japanese craftsmen, as well as serving the very narrow circle of court and aristocracy, also tried to make the lives of the masses more enjoyable. The belief that it is not enough to create objects of perfect workmanship

for the court and aristocracy alone has survived unchanged into the production system of modern industrialised Japanese society. Perfection and durability were the aims of workmanship in old Japan, and constant devotion to work for its own sake is necessary for these aims to be achieved. Labour is not simply a painful activity; it is a means of testing the level of perfection of our own abilities by creating objects of perfect workmanship. For this reason the tools that help a man in his work and that extend the range of what he can do are often personified and regarded as having life and suffering death in the same way as a man. The date on which a tool was first used is often recorded in writing on its surface—this is the day the tool came to life. And when the tool has been in use for a long time and is no longer serviceable, it is ceremonially buried.

The Japanese people's innate feeling for beauty and the high importance they attach to work are characteristics that have continued virtually unchanged from the pre-industrial to the industrial age, and many of the industrialised products of modern Japan possess these age-old virtues in modern form.

Since so many traditional Japanese goods were made with the popular market in mind, one often finds in their designs a certain exaggerated humour, as many foreign observers have pointed out in recent times. Even tiny objects such as *netsuke* can be powerfully expressive and filled with unexpected or even grotesque humour, and the elegance that we have taken as a key aspect of the Japanese conception of beauty often contains within it a grain of humour, for this is something that runs through the whole of Japanese and, for that matter, Western culture. Even the most glorious life will end in darkness and death; holiness and profanity, splendour and gloom form the dual basis of man's culture. In spite of its sometimes idiosyncratic manifestations, Japan's culture, like any other, draws its essential vitality from the universally dualistic phenomenon of human existence.

Madame Butterfly in a Rabbit-Hutch: Western Perceptions and Stereotypes of the Japanese

Jean-Pierre Lehmann

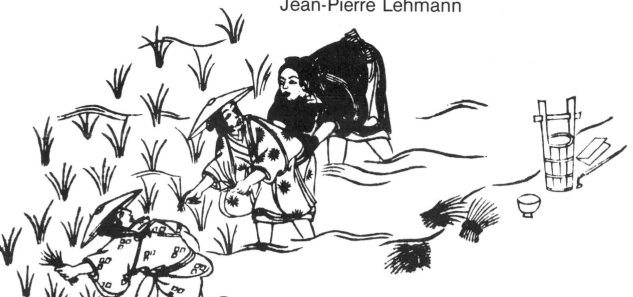

In the narrative of his extraordinary travels and adventures Marco Polo occasionally referred to an island country lying to the east of China which he called *Jipangu*. He may, therefore, be at least partly responsible for the fact that we call that country Japan (or le Japon, il Giappone, el Japón, etc.). In Japanese it is either Nippon or Nihon, the choice being somewhat dependent on the individual or on the national mood: Nippon is rather masculine and connotes an attitude of assertiveness, defiance or belligerency, while Nihon is somewhat more gentle, more feminine and thus perhaps more accommodating. The West first heard about Japan from China, and the Chinese reading of the two characters for Nippon is Jih-pen.

Marco Polo, however, never visited Japan, and indeed it took almost another three centuries before the first Western foot stepped on Japanese soil. It was in the mid-sixteenth century that Iberian missionaries and traders arrived, to be followed within a few decades by their enemies, the Dutch and the English. This turbulent and exciting period of Japanese history is the subject matter of James Clavell's best-selling novel *Shogun*, with Will Adams, the first Englishman in Japan, as the hero. In the course of the first few decades of the seventeenth century, however, all foreigners came to be banned from Japan, with only two exceptions: Chinese merchants were granted access to the port of Nagasaki and the Dutch obtained permission to maintain a small trading post in the islet of Deshima.

Although some information regarding Japan filtered out to the Western world, generally she remained hidden behind a seemingly impenetrable veil of secrecy. The American Commodore Perry's "opening" of Japan's doors in 1854, however, heralded the advent of a new age. Japan's contact with the outside world was renewed, but this time on a much more intensive and international scale.

In the last thirteen decades many things have happened in the relations between

Japan and Western countries; many books have been written, many dreams have been born, in some cases fulfilled, and some tragic nightmares have been endured. All of these have provided ample material for the creation of Western images and stereotypes of the Japanese.

In one nation's perception of another—especially when the nations are as distant from each other as Europe and Japan—an element of fantasy may at times creep in. Perhaps the most prominent feature of the Western image of Japan in the latter part of the nineteenth century was the belief that the country was inhabited by the most exquisite females on earth. In itself that is not necessarily complete fantasy; but when the poet Alfred Noyes, in a poem entitled "A Japanese Love Song", enthused about a Japanese maiden in these words—

> Though the great skies are dark,
> And your small feet are white,
> Though your wide eyes are blue (*sic*),
> And the closed poppies red ...

—his imagination had obviously got the better of him as to the shape and colour of his idol's eyes.

Generally, however, stereotypes are based on real experiences, even if these experiences belong to the past and no longer necessarily apply to contemporary reality. Indeed the past is probably more influential than the present. Because of the last war, the fact that the Japanese may still be perceived by at least some Westerners as "the enemy"—even though the battleground may now be economic rather than military—is something which by and large has to be accepted and which only time will heal. An illustration of this can perhaps be suggested by the probability that even Westerners who have never been to Japan, and never evinced the slightest interest in her, are nevertheless likely to know at least two Japanese words, one of which is *kamikaze* (the other is *geisha*).

Even the more hostile impulsive reaction towards the Japanese is not always lacking in humorous side-effects or consequences. At least for those generations born before 1945 there will probably always remain a feeling, extending from conviction to suspicion, that basically the Japanese are cruel. Now as everyone knows (talk of stereotypes!) what the British people love above all else are their dogs. In 1969 a British journalist returning from Japan published a piece in a national newspaper alleging that the Japanese were cruel to dogs. An outcry ensued and there were loud protestations that henceforth all exports of British dogs to Japan (the trade deficit was not in 1969 what it is today) should be banned. This British outrage was reported in the Japanese press with the result that there followed what must have been one of the oddest demonstrations in the history of the world: the solemn, awe-inspiring British Embassy, situated opposite the Imperial Palace, was besieged by a mass of human and canine marchers, the former vociferously protesting that they were not cruel to their dogs, while the latter bow-wowed agreement in chorus.

One might briefly pause here to consider some of the features of stereotyping

which emerge from this incident. "Cruelty" is generally a relative and subjective phenomenon. Thus, by English standards it is true that the Japanese are "cruel" to their dogs; they tend to keep them confined in small enclosures or tied by a rope. By Japanese standards, however, we are "cruel" to our children; Japanese children are not spanked, rarely scolded, they tend to be breast-fed until a more advanced age, they will generally sleep with, or in very close proximity to, their parents and they will not be left in the care of a babysitter while the parents go out to paint the town red. The differences are diminishing with time: the Japanese are less "cruel" to their dogs than they were, we are less "cruel" to our children than we were (with Dr. Spock, depending on one's viewpoint, either to thank or to blame). Still, from our perspective we might be tempted to say that the Japanese "indulge" their children, while a Japanese might feel that the British "indulge" their dogs: hence the Japanese remark that whereas Japan is a paradise for children, England is a paradise for dogs. It is also clear that there is always an element of hypocrisy lurking in a stereotype's background. While on the subject of animals, for example, one might mention that the Japanese do not engage in blood-sports, nor is shooting a popular form of leisure.

So far as the contemporary scene is concerned, stereotypes are usually founded on some aspect of reality, though with the result that a single aspect can become distorted, exaggerated, either embellished or sullied. When the anthropologist Ruth Benedict was commissioned by the U.S. government in 1944 to carry out research on Japanese society, one of the things which most interested her was that Japan appeared to be a nation of such amazing contrasts. For any positive assertion, the converse seemed equally true: the Japanese are the most gentle people, they can also be the most hideously brutal; they are the most hospitable people to foreigners, they are also the most xenophobic. She entitled her work *The Chrysanthemum and the Sword*, thereby hoping to convey the stark contrasts which she felt coexist within the same society.

Equally great contrasts can be found in Western stereotypes of Japan. Perhaps one might suggest that this arises from the fact that whereas some have chosen to completely ignore the chrysanthemum and concentrate their attention entirely on the sword (today more likely to be the *soroban*—abacus—or perhaps the miniature pocket calculator), others forget the sword and extol the chrysanthemum. The Japanese, it is said, are undoubtedly the most materialistic people on earth, whatever spiritual values they once had have now been completely washed away by the tide of time, prosperity and greed; the name of the country is "Japan, Inc.", its inhabitants are "economic animals" and the national religion is "GNPism". The Japanese (runs the contrary view) are the most ascetic race in the world; it is they who perform the tea ceremony (*cha-no-yu*), who are incomparable in the art of flower arrangement (*ikebana*), who have fashioned the most sublime rock gardens, and, in view of the current craze for Zen, they are clearly a meditative, spiritually rich people who know how to escape from the tawdry mess of contemporary reality.

Japan is one of the very few countries of the non-Western world which was not colonised; so far as early Western attitudes towards the country are concerned, however, they could perhaps be described as quasi-colonial. But, of all the country's treasures, what the Western imagination sought to possess above all was the Japanese female; no women from foreign lands captivated the hearts and minds of Western males so much as the ladies from Japan. A word entered the English vocabulary, the *musmee* (from the Japanese word *musume* meaning daughter or young woman), which was supposed to convey all the charm, the grace, the delicacy, the exoticism, the beauty, and the availability, of Japanese girls; the word has disappeared from the English language, but *une mousmé* is still current in French, today perhaps equivalent to (and as respectful as) the use of the word "bird" in referring to a young woman.

Western novels, poems, operettas, etc. in which figure a romance between a Japanese girl and a Western man abound, the most famous being Pierre Loti's *Madame Chrysanthème*, which was the inspiration for Giacomo Puccini's *Madama Butterfly*. Although by the first decade or so of this century, at least in quantitative terms, the output of literary and other works on this theme abated, the genre nevertheless remained. There were, for example, the works of Frank Ashton-Gwatkin (with the nom de plume John Paris) and the exceedingly funny, though tragically ending, *L'Honorable Partie de Campagne* (*The Honourable Picnic*) by Roger Poidatz; Poidatz chose as his pseudonym Thomas Raucat, homonymous as it is with the Japanese *tomarō-ka*, which can be interpreted as "Shall we stop here for the night?". Not surprisingly the thirties and forties brought a halt to this particular industry, though immediately after the war there appeared Richard Mason's moving novel *The Wind Cannot Read*, shortly followed by James Michener's *Sayonara*. In the decades since the war the theme has continued in a number of (generally mediocre) works, the latest (1976), to my knowledge, being John Drew's *Seven Nights in Japan*, which was made into a film starring Michael York and Hidemi Aoki.

There have been a few instances in which the roles are reversed, namely Japanese male and Western female, perhaps the most widely known being Alain Resnais' film *Hiroshima Mon Amour*; these, however, are rare. So far as the more general use of the theme is concerned, however, and irrespective of the creators' intentions, all these works have, to varying degrees, contributed to several Western images of Japan. Certainly they have cast Japan in a romantically exotic glow. They have also provided a feminine picture of the country and its inhabitants; indeed, it has been alleged that one of the reasons why the czar's court did not take seriously Japan's threat to go to war in 1904 was that the only knowledge they had of the country was derived from reading *Madame Chrysanthème*. Be that as it may, at least some of these works have also tended to give the impression that the morals of Japanese women are loose. In the Victorian age this belief was also encouraged by descriptions of certain Japanese customs, notably that of mixed bathing. The stereotype of Japan as the permissive society *par excellence* is

perhaps less prominent today than it was for several decades; nevertheless, I cannot be the only person who, upon returning from Japan, has been invariably asked at some stage or another, "what about the geisha, then?", with the inevitable accompanying nudge in the ribs.

Patterns and perceptions of moral behaviour vary significantly in both time and space; the question of Japanese sexual mores is, therefore, far too complex to be treated adequately in just a few sentences. Generally, the comments made about the relativity and subjectivity (and hypocrisy) of "cruelty" would equally apply to "morality". Images, by definition, are caricatures. The torch of promiscuity—in terms of reputation, not necessarily in terms of reality—passed from the Japanese, to be held for a long time by the French, whereas now it would appear to be firmly in the grasp of the Swedes. But the exotic appeal of Japanese girls, so deeply ensconced in Western literature and folklore, will no doubt endure. Here, however, it might only be fair to warn aspiring Pinkertons with illusions of easy conquests that they may be in for a bit of a disappointment. As to Western perceptions of the *geisha*, the orthodox interpretation was that she was a prostitute; orthodoxy inevitably gives way to revisionism, with the result that some of the writing on the subject today would lead one to believe that *geisha* are Sisters of Mercy. The truth, as often happens in such cases, lies somewhere in between the two extremes.

Regarding other features of Japan's development during the last century or so, it is not surprising that the West has reacted with considerable perplexity. As Japan became industrialised and a formidable military power, she seemed to be defying the rules of the game—rules invented by the West, but which seemed on the evidence to be appropriate. Europeans were the conquerors, the Asians the conquered; Europeans produced manufactured goods, Asians raw materials; Europeans, imbued with the puritanical protestant ethic, were successful entrepreneurs, Asians were backward, decadent and unduly given to the pleasures of the senses. Then came the Japanese! In 1905, to the astonishment, and in some cases panic, of the West, Japan defeated Russia in a major war. By the time of the 1914–18 war the Japanese were competing in hitherto exclusively Western markets in the sale of manufactured goods, while the vessels of their merchant marine plied the oceans of the world. In due course the names of such mammoth concerns as Mitsui, Mitsubishi, Sumitomo became familiar. Today a typical European family is likely to drive a Honda car, watch a Sony colour television set, play a Yamaha piano, and so forth. (The English author, Lewis Bush, recounted how on one occasion he went to visit one of the first Suzuki-method schools of violin playing in Kent; taking a five-year-old pupil aside he asked him, "Do you like Mr. Suzuki's violins?", to which the little boy quickly replied, "Oh yes, and when I grow up I shall buy one of his motorcycles".)

Well, how did all this happen? Why Japan successfully modernised is due to a multiplicity of factors which need not detain us here; but certainly one of the more common Western instant explanations has been that the country underwent a thorough process of occidentalisation. Quite a number of Western visitors to Japan

from the Victorian age onwards fall into a category which one might classify as the "conservationists"; they strongly felt that the country should conserve what they perceived to be the essence of Japan, and should not sacrifice it at the altar of vulgar Western material progress. For example, Kipling, visiting Japan in 1889, was completely taken by the charm and beauty of the country, but at the same time he expressed considerable anxiety about the damaging effects of European and American influences; he wrote, "It would pay us to put the whole Empire in a glass case and mark it *Hors Concours*, Exhibit A". The alleged metamorphosis from Oriental to Occidental has led a number of Western observers of Japan, such as the Dutch novelist Louis Couperus in the early part of this century and more recently James Kirkup in his last book, *Heaven, Hell and Harakiri*, to accuse Japan of having lost her soul. Thus the view of Japan as thoroughly westernised serves two purposes: it explains why an Asian nation could beat the West at its own game, and at the same time consoles the anti-Japanese lobby because of the clear implications to be drawn from this story of a latter-day Esau who sold his birthright for a pottage of GNP.

Japan is an industrialised society and industrialisation tends to make equals of us all, at least so far as external appearances are concerned. That the nation has changed over the decades is an indisputable and inevitable fact, that a degree of westernisation has taken place is true, that the result of all this is that Japan should no longer be situated culturally in the Far East, but in the Far West, is rubbish. It has been a characteristic of Japanese civilisation and a measure of its genius over the last millennium-and-a-half to import certain products, ideas, techniques, fashions from outside and to adapt these to the indigenous milieu. The Japanese have retained their soul, their personality, their individuality, although these have ineluctably evolved as external circumstances have changed.

Another Western stereotype of the Japanese is that they are a nation of sheep, in the sense that the Japanese islands are inhabited not by so many individuals, but by one enormous collective flock. We tend to exaggerate this trait, as the Japanese are equally naive in perceiving Western countries as being populated by nothing but robust individualists. We are far less individualistic, while the Japanese are less collectivistic than is often made out. Nevertheless, owing to both cultural and demographic factors, there is a difference, and it is true that generally speaking there is less manifestation of individualism in Japan than in the West.

This can sometimes make the importing of certain Western products hazardous. A Japanese friend of mine told me a story in order to illustrate the group impulse of his compatriots. At a time when the Japanese phoenix was rising from the ashes, when the deprivations of the war and the immediate postwar period began disappearing and a degree of prosperity appeared, as had previously happened in the 1870s, a mania for foreign things gripped the nation. The Bardot hairstyle was popular with girls as the Presley "duck-tail" was with young men. In the general scramble for introducing sundry facets of Western civilisation to the Japanese, one promoter had the genial idea of otaging a bullfight in Tokyo. The huge Kōrakuen

stadium was chosen as the venue and months beforehand tickets for this affair had been sold out; in the meantime, matadors, picadors, banderilleros, horses, and, of course, the bulls were being shipped from Spain. On the appointed day the crowds filed into the stadium and took their seats; the event began, as is the custom, with the trumpets blaring *pasa dobles* while the matadors strutted across the arena. The parade over, the matadors took up their position, the first bull was set loose. But nothing much happened. The bull was dissolutely roaming about, while the spectators watched the proceedings in complete silence; it began to look as if the affair would end up as a flop. Then a voice came over the loudspeaker explaining to the aspiring *aficionados* that in Spain, in order to encourage both bull and matador, it is the custom to shout "olé". The consequence of this elucidation was that at regular intervals of six-and-a-half minutes fifty thousand people shouted in unison, "oré" (the Japanese language having no "l", they tend to substitute it with the "r"), with the result that both matador and bull were in grave danger of dying from heart seizure, rather than the former being pierced by a vengeful horn or the latter dispatched by a skilful *estocada*.

What about "workaholism"? A number of years ago the Italian writer Fosco Maraini was taking a Japanese friend of his, in Europe for the first time, around Rome. They reached the Vatican and entered the Sistine chapel. Maraini began explaining to his friend the story of Genesis as together they followed the details of Michelangelo's frescoes; as they reached the bit about Eve, the apple and the banishment from the Garden of Eden, he added to his attentive partner, "and so, as punishment Adam and Eve were forced to work". The countenance of the Japanese suddenly changed dramatically and in the most startled manner he cried out, "What? Work is punishment?". As Fosco Maraini subsequently pointed out, there is nothing in the traditional Japanese religions or philosophies—whether the indigenous Shinto or the centuries-old imported Buddhism and Confucianism—which sets out work as punishment; on the contrary it is perceived as a reward.

There are certainly cultural phenomena which help to explain why the Japanese, if not necessarily addicted to work, are less allergic to it than we are. There are also other reasons. One is that Japan is very poor in natural resources and hence dependent on the maximum use of human resources. Another reason has to do with their living environment; it is a fact that in many cases the working-place is more comfortable, or at least less cramped, than the dwelling-place.

Is it true then that they live in "rabbit-hutches"? The short answer is yes—but they call them "mansions". The craze for Western things has extended to the language, but the adopted Western word may not necessarily have the same meaning, or convey the same sense, as its original. A hypothetical Mr. Tanaka will give as his address "Blue Hill Mansion", but the building may be grey, located in the flattest section of town and the quarters he and his family occupy may be limited to two small rooms, plus kitchen and bathroom.

Two fairly obvious points should be made. Firstly, Japan has a population of some 115 millions living in a country whose total land mass is only about two-thirds

that of France, but more than 80 percent of which is mountainous and uninhabitable. Secondly, although modern building techniques have been perfected to a considerable extent, it is nevertheless the case that Japan cannot build too high because of frequent earthquakes. It follows that there is not much space for living accommodation, vertically or horizontally. Perhaps a general observation can be made which, I hope, may help to put the question of the "living environment" into perspective. Japan, it must not be forgotten, has only recently become an urban society. The transition from an agrarian rural economy to a predominantly industrial urban setting was accompanied, as elsewhere, by some wanton destruction and rapid, sordid construction. This was particularly true of roughly the two decades which followed the war; it cannot be denied that during this period the appearance of Japanese cities was one of fairly unadulterated squalor. But just as Japan has not lost her soul, she has not lost her ascetic sense of beauty. Today new forms in architecture, design and urbanisation are being sought and not without a considerable degree of success. In more recent years the urban landscape has undoubtedly and markedly changed for the better; Japanese cities are becoming more attractive and comfortable places to live in.

Of course a great deal of improvement remains to be carried out, and the problem of living conditions should, and probably will, become a matter of national priority. In the meantime, however, there has been a trend over the last few years, generally referred to as *mai-hōmu-shugi* (my-home-ism). The *mai* (my) here denotes an attachment to private property and the private domain, a reaction against the self-sacrificing collectivist ethic, but one which some Japanese decry as evidence of selfishness rather than individualism. It could perhaps be described as the Japanese variant of "cultivating one's own garden". The *mai-hōmu-shugisha* (my-home-ists) advocate disintoxication from "workaholism" and a concentration of efforts on improving the quality of the individual's own environment. This is a phenomenon to be found primarily among the younger generations of the middle class; whether it is the wave of the Japanese future and what its consequences are likely to be is impossible to say.

Western stereotypes of the Japanese should be seen in terms of a moving mosaic; it moves along the passage of time, though not necessarily at the same pace. There are bright flashes in some places, dark patches in others. How far have Western perceptions penetrated the reality? This is an impossible question to answer, but a few considerations should be borne in mind. The veil we mentioned earlier has been lifted—gently or otherwise—not torn asunder. Partly because of this, the constant *leitmotiv* of the stereotype mosaic has been that the Japanese are inscrutable. Often, and for good measure, to this alleged trait of inscrutability will be added those of secretiveness, humourlessness, suspicion of foreigners and inhospitability. Many Europeans, including myself, have found that this is simply not the case; on the contrary, there is hospitality, a great sense of fun, generosity and warmth, the likes of which can seldom be encountered anywhere else.

Nonetheless, one can understand why this impression should arise in the

Western consciousness of Japan. One must not underestimate the rather formidable linguistic and cultural barriers. This, it might be countered, is surely the case with other non-European societies. Perhaps, but Japan remains, for the time being, the only non-Western fully-fledged industrial power, having indeed, as suggested earlier, beaten the West at its own game. To the possible frustration arising from the difficulties in overcoming these barriers there is also, it would seem, a fairly strong element of jealousy and resentment. From that viewpoint, it is clear that being told that the Japanese are "workaholics living in rabbit-hutches" has a rather soothing effect. How the Japanese may respond to these epithets is clearly not the major preoccupation. In cases such as these, not only is there wild exaggeration, there is also an obvious lack of tact and sensitivity.

So far as inscrutability is concerned, however, the Japanese themselves cannot be entirely exonerated. In order to illustrate the point we wish to make here, let us briefly return to Fosco Maraini. Maraini explained the frescoes of the Sistine chapel to his Japanese visitor; he did not, however, assume that the latter would be incapable of understanding. The obverse would not necessarily be the case. The Westerner visiting, say, the famous garden of the Ryōan-ji in Kyoto will, as likely as not, be told by his Japanese host that he cannot "really understand". The Japanese in Britain who speaks English fluently may be looked upon with some admiration, while the Westerner speaking fluent Japanese may be regarded in Japan in a manner approximating to the sudden apparition of the yeti. All of this is comprehensible to a certain degree. Reasonably fluent Japanese speakers of European languages are not that rare, while fairly fluent Western speakers of Japanese are—though not quite as rare as the yeti. In the Western consciousness of its own culture there is an assumption of universality (born, perhaps, of arrogance) which simply does not exist in Japan. The same is true of food. The Japanese will tend to be amazed at a European who says he actually likes *sashimi* (raw fish), while an Englishman will serve his hapless Japanese guest boiled mutton with mint sauce without a moment's hesitation. Clearly there are differences. The ideal prescription, surely, is for Westerners to make greater efforts in overcoming the barriers, while the Japanese on their side might strain a bit more in attempting to lower them.

Let us attempt to see what the perspective might be from the bridge spanning the Japan-West gulf. When glancing at the West and assessing attitudes towards Japan, one tends to find that these oscillate between affable condescension and mistrustful disdain. The insulting manner in which they are often expressed reveals a high degree of insensitivity. When attention is focussed on the Japanese, they seem to react with occasional hyper-sensitivity. Stereotypes are quite simply a fact of life; one should not over-react to injurious remarks, especially when, as is often the case, they are uttered in ignorance. Also, perhaps the Japanese sometimes forget that stereotyping and insensitivity are by no means a monopoly of the West; they too are guilty of perceiving others in terms of (not always flattering) stereotypes. Surely, what is rather desperately needed is far greater maturity on both sides.

Japan is very far away from the West. This is hardly a statement of revolutionary novelty. It needs, however, to be emphasised. Although Japan has retained her indigenous culture, at the same time it is clear that we have also a great deal in common. We should know each other far better than we do. Unfortunately, however, Japan is not only far away in terms of distance, but also in terms of expense. No Sir Freddie Laker has yet appeared to work miracles. So long as Japan remains difficult of access, it will probably be the case that misconstrued stereotypes will continue to influence Western perceptions of the country and its inhabitants. In the meantime, however, one can express the hope that exhibitions, such as the present one, may help to dispel some of the misunderstanding, and arouse greater interest, curiosity and appreciation for this remarkable society. Japan is enchanting, she is also perplexing, indeed at times exceedingly frustrating, to the point of being infuriating; but, in whatever guise she may appear, and in whatever mood we may approach her, she always remains supremely fascinating.

JAPAN

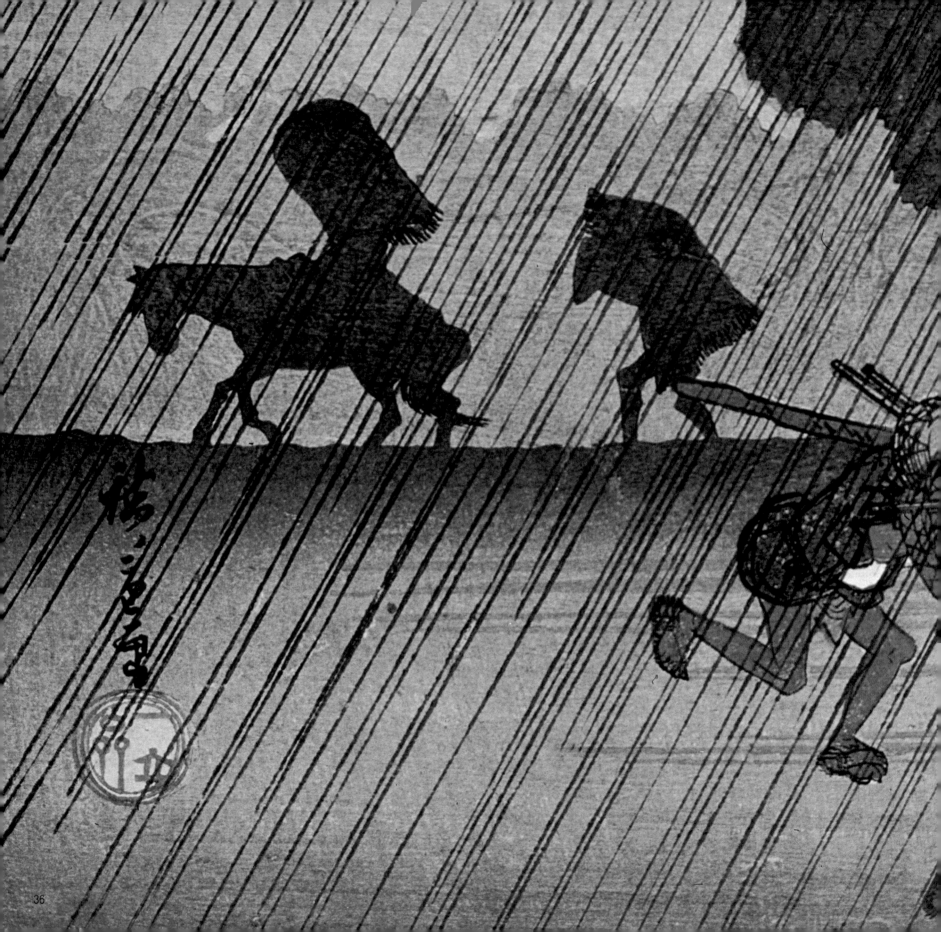

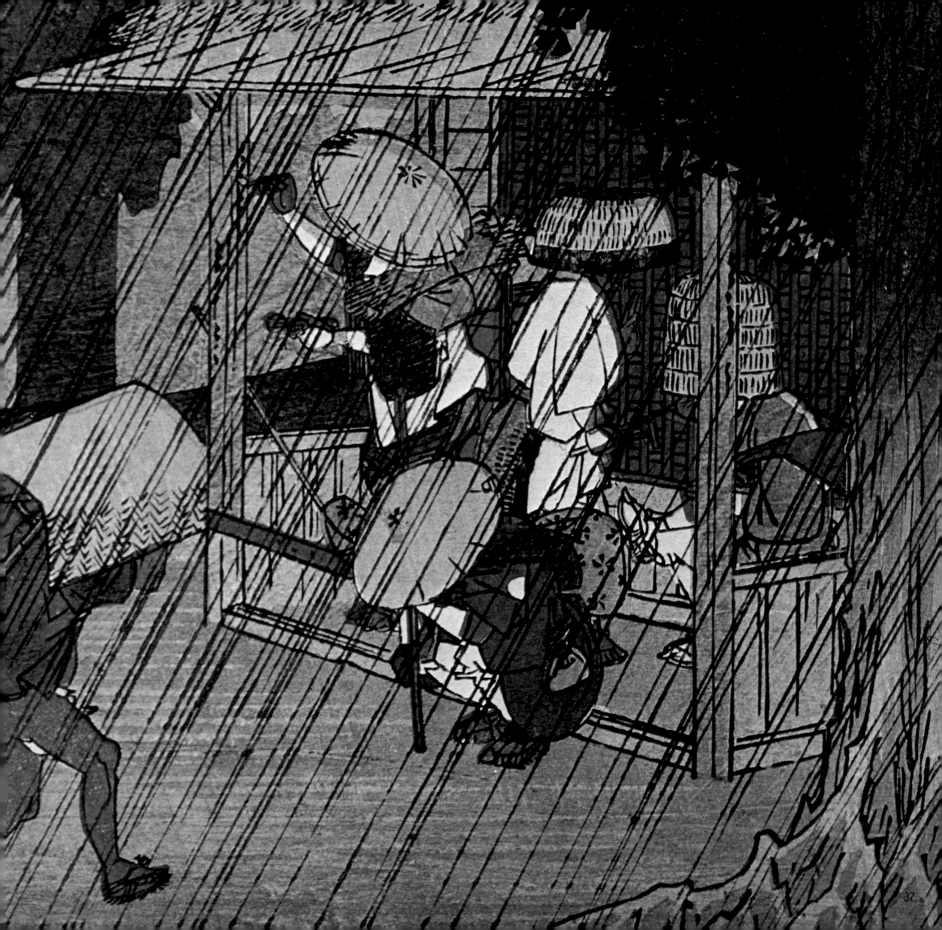

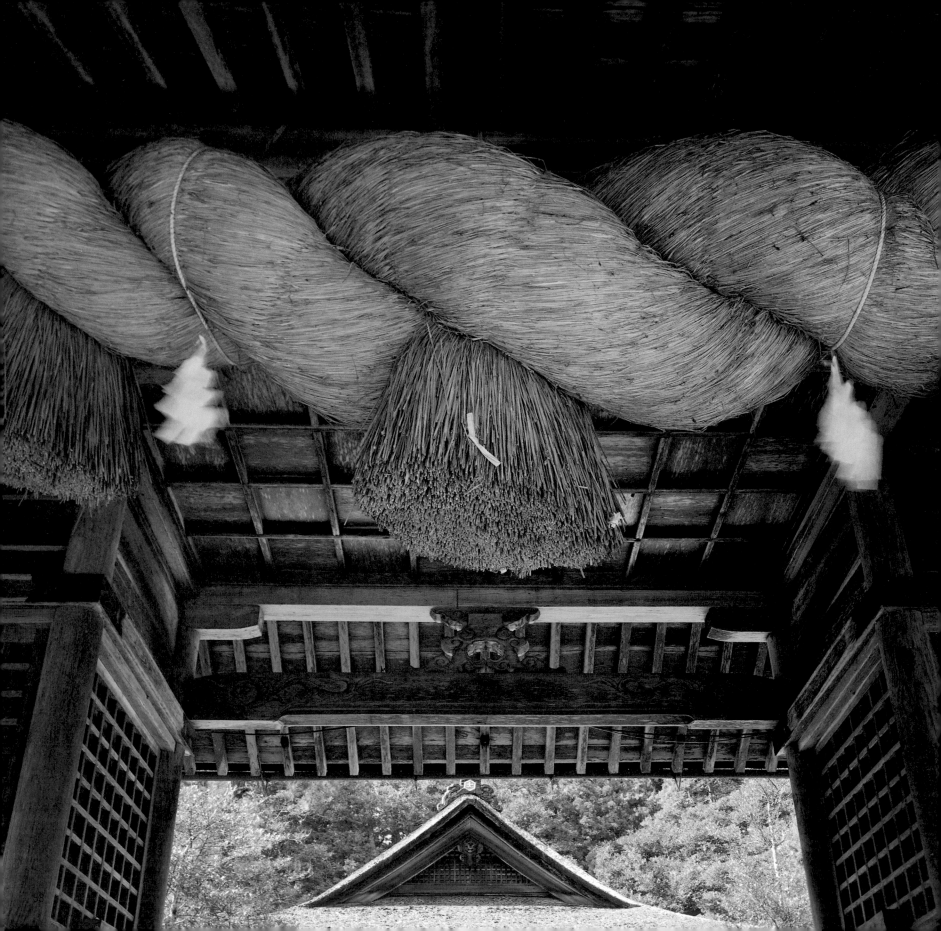

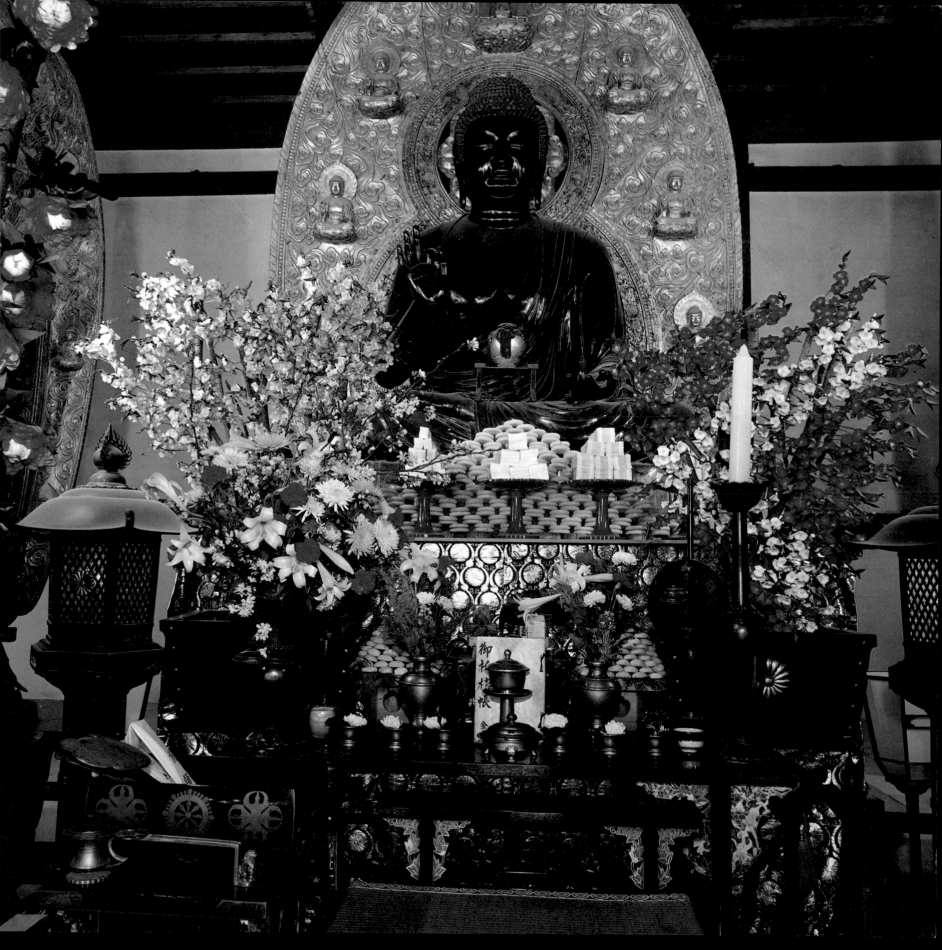

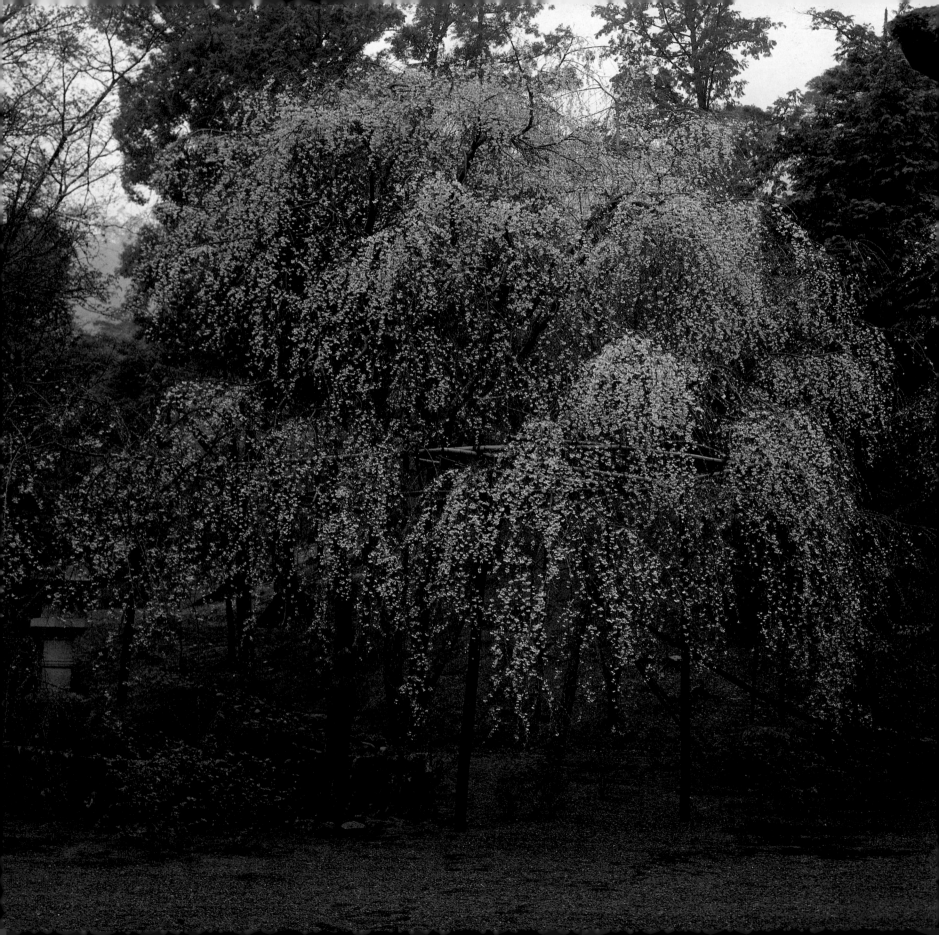

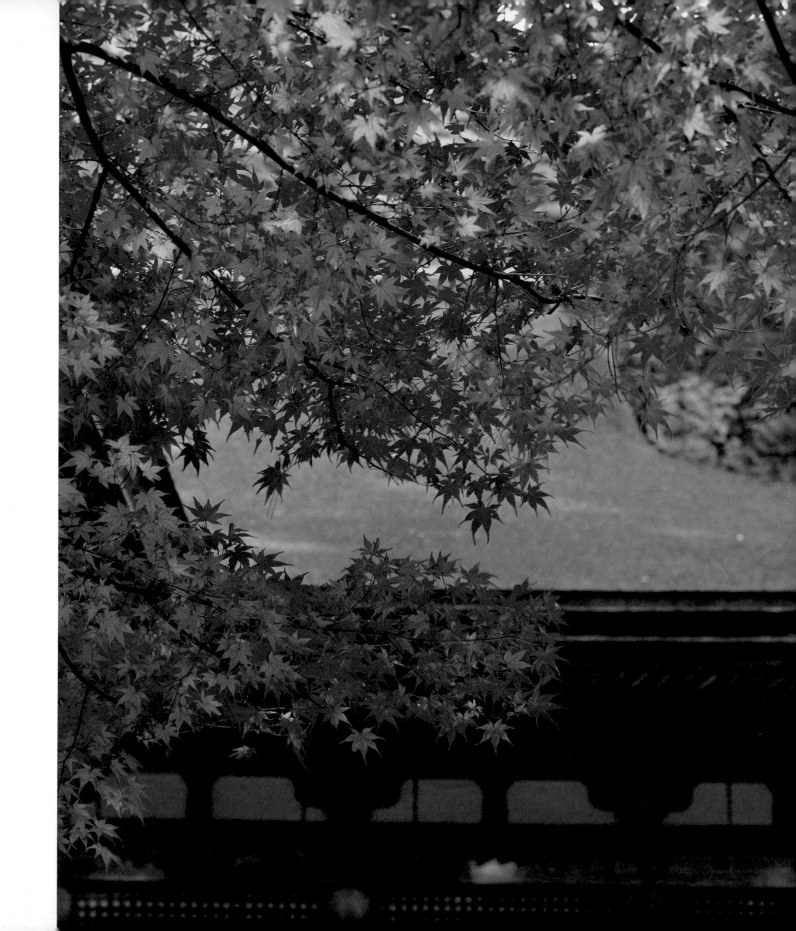

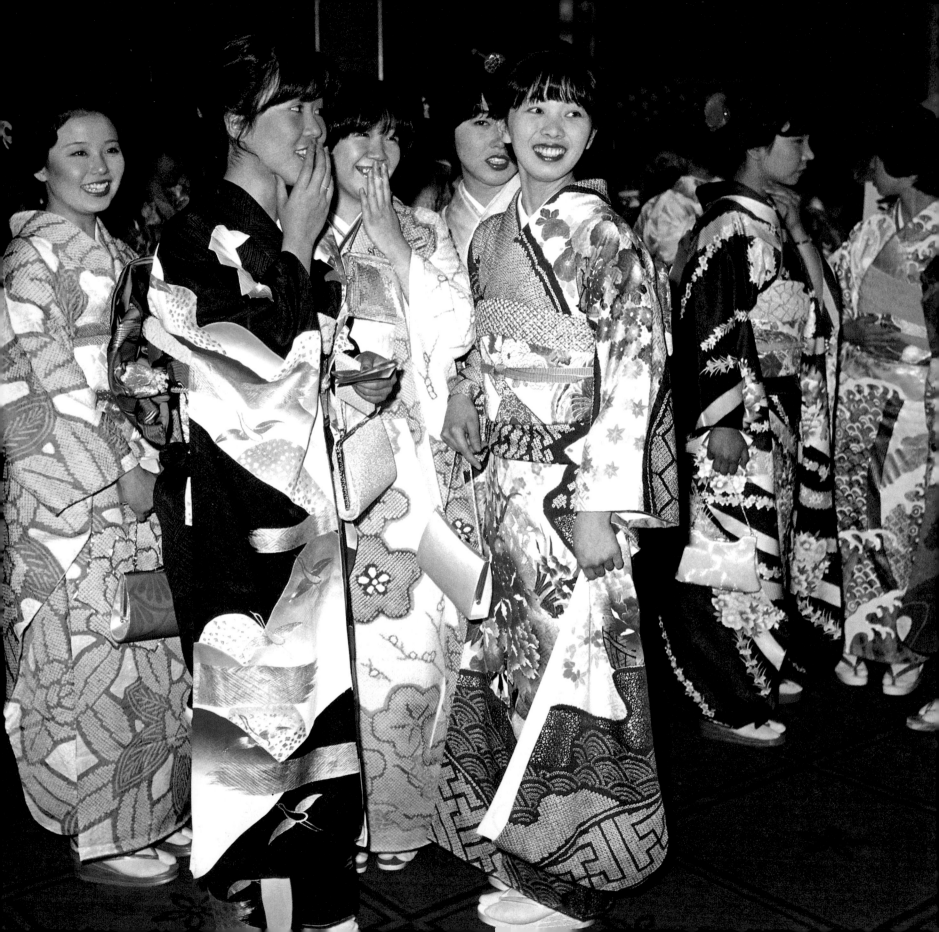

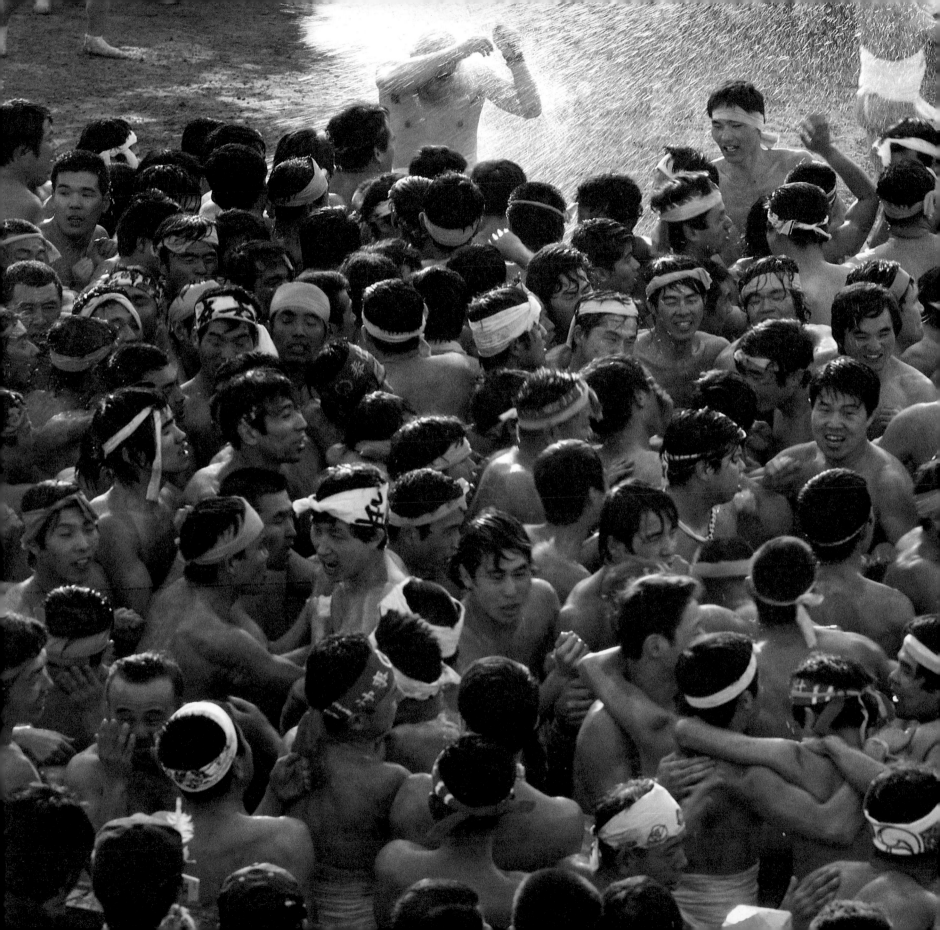

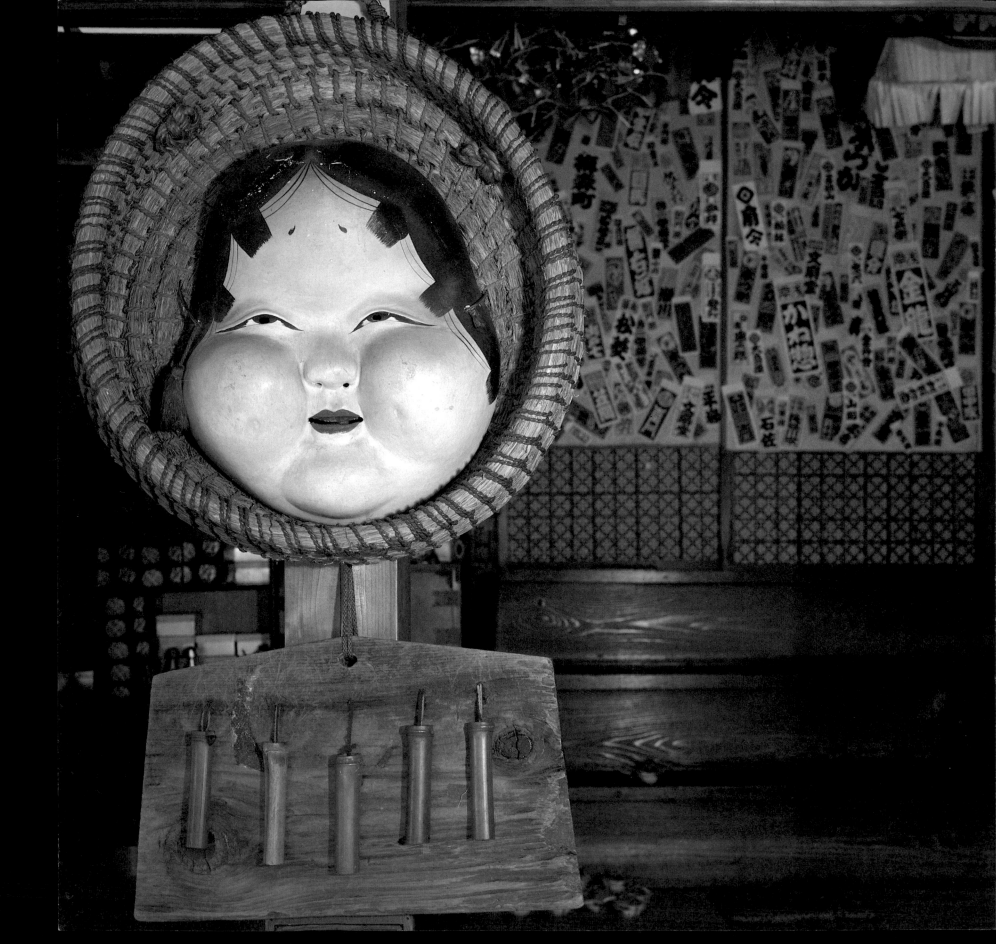

MATERIALS

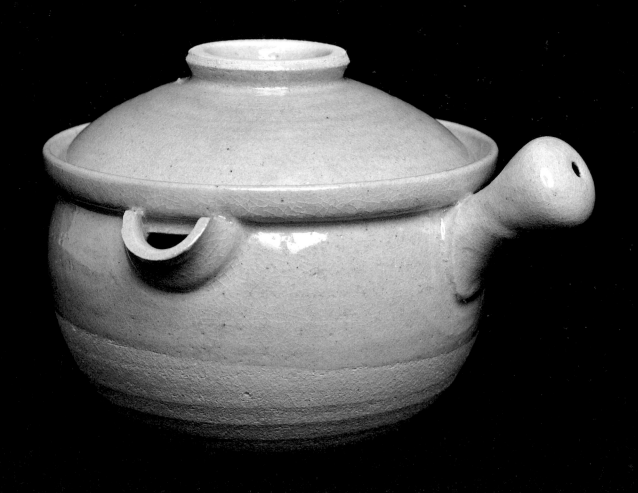

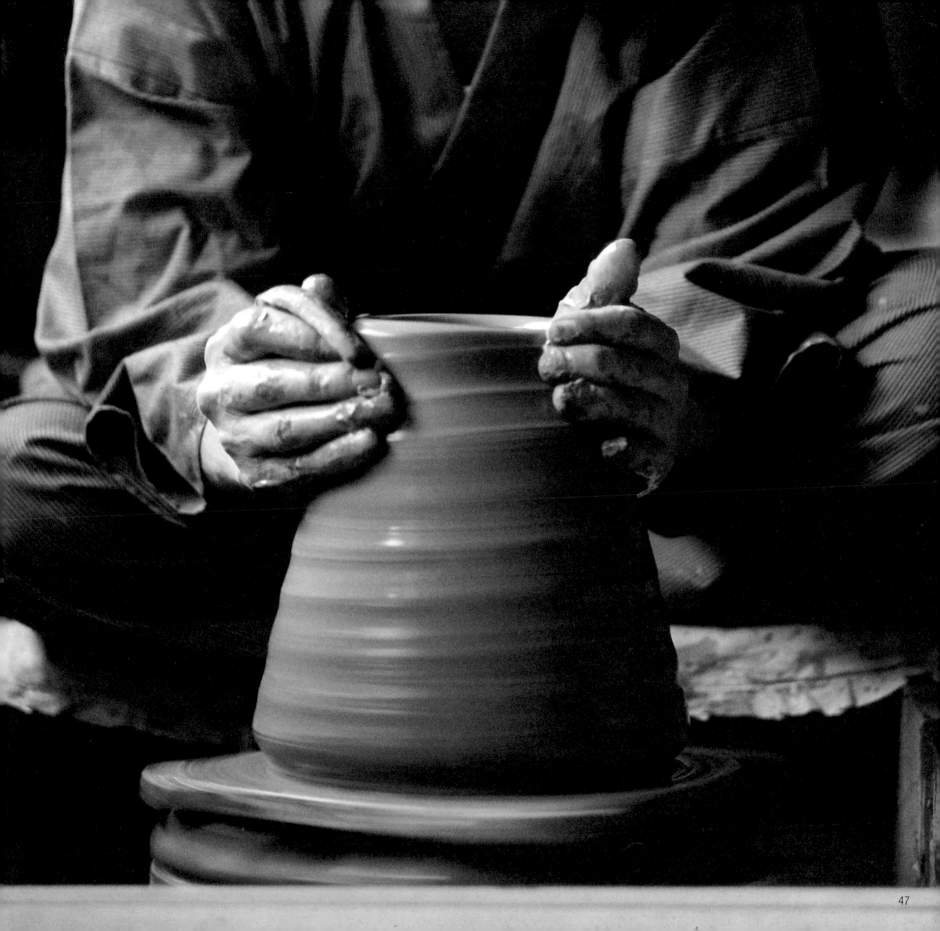

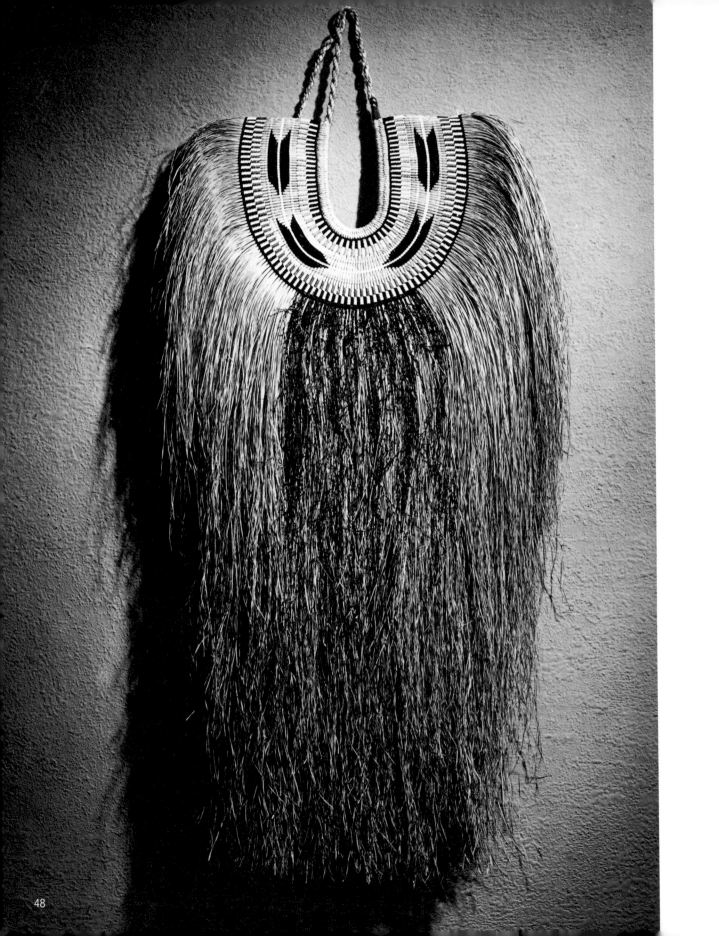

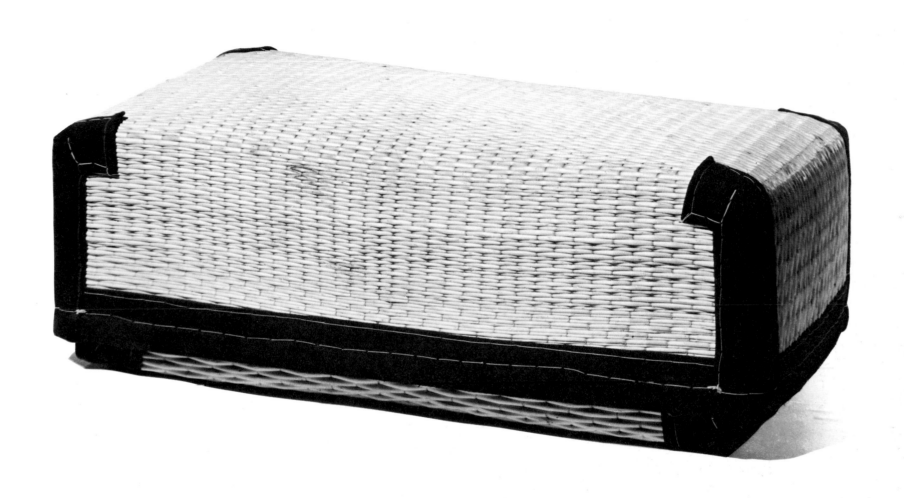

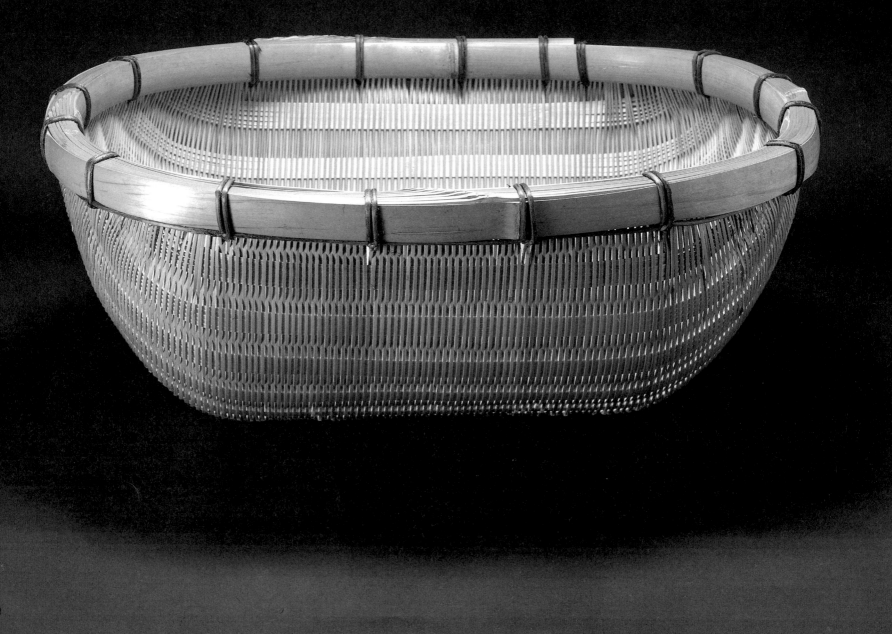

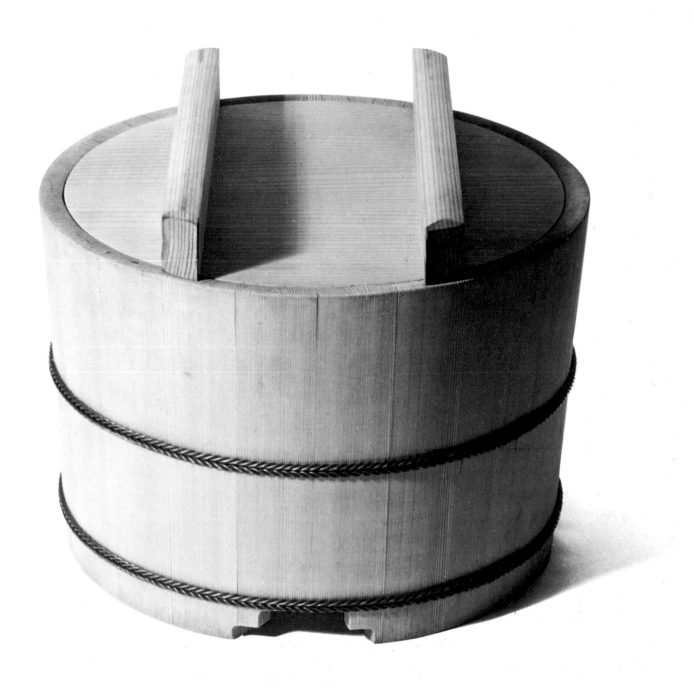

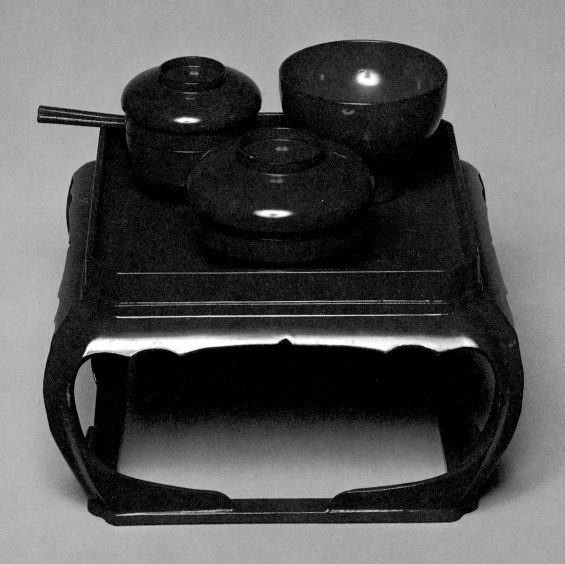

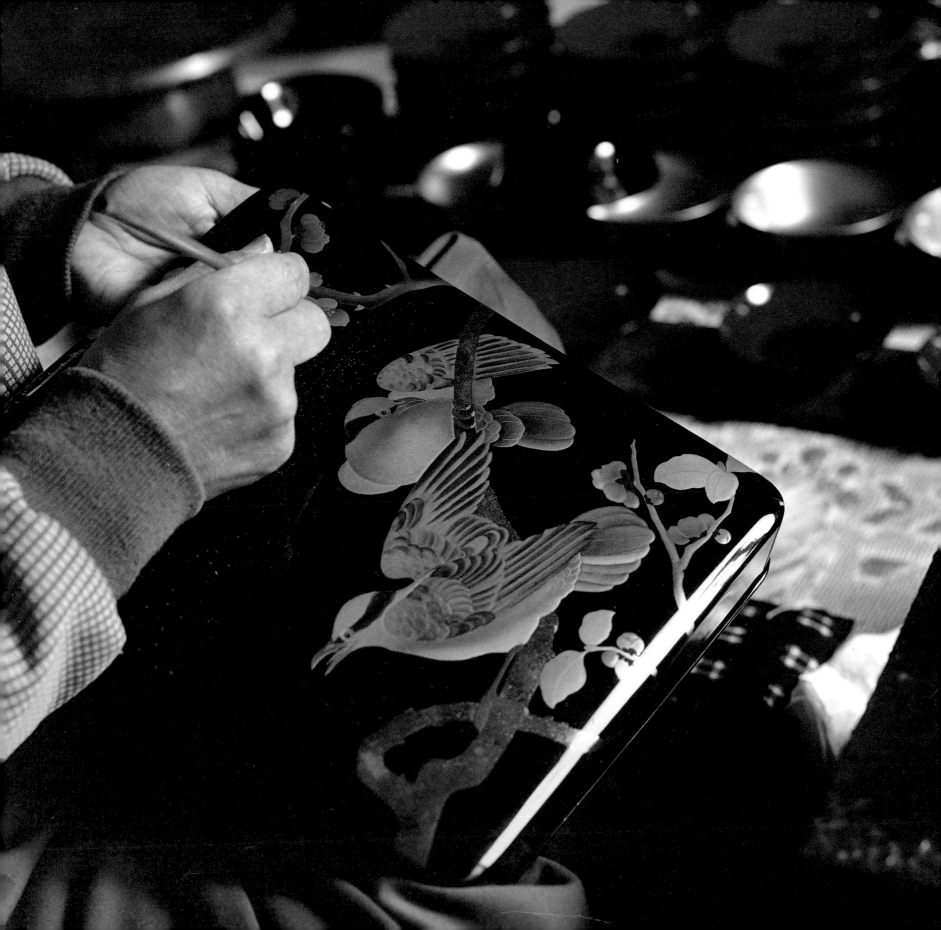

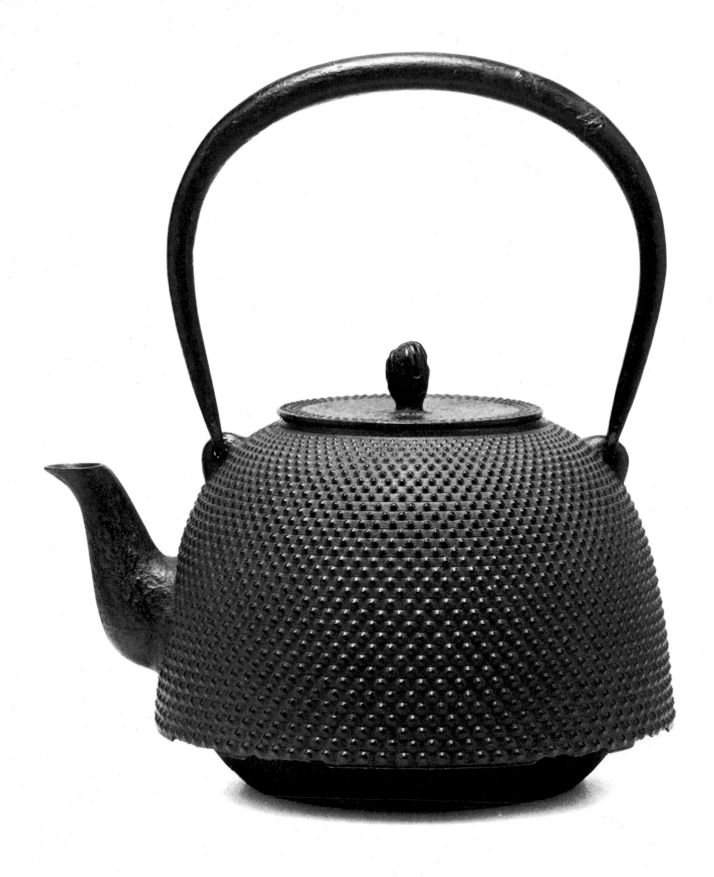

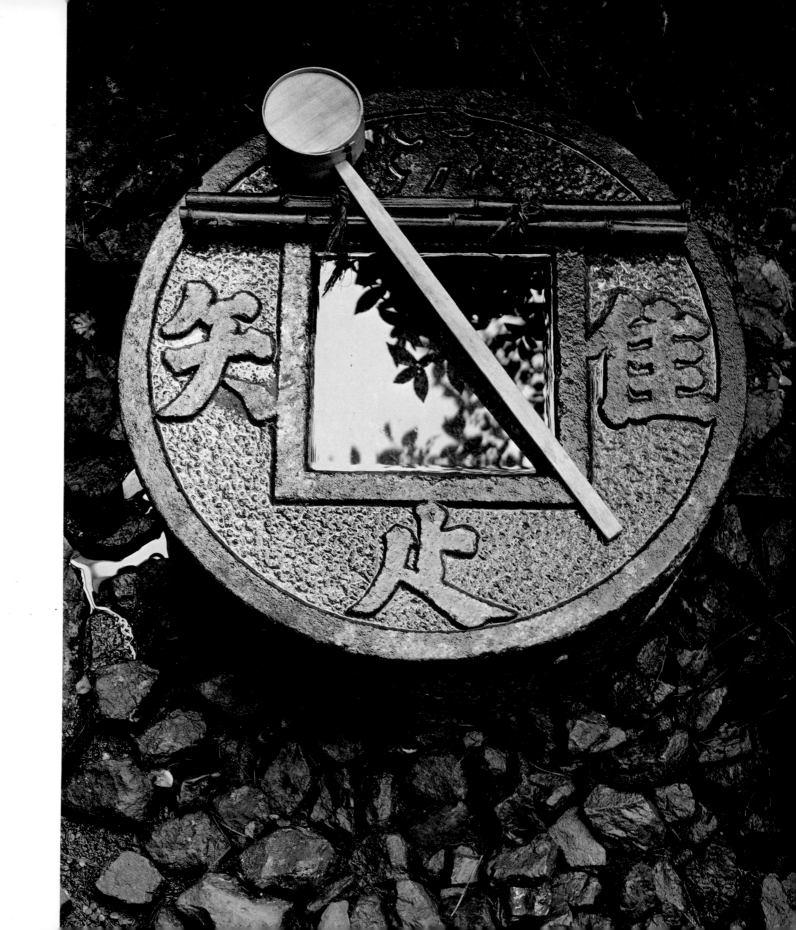

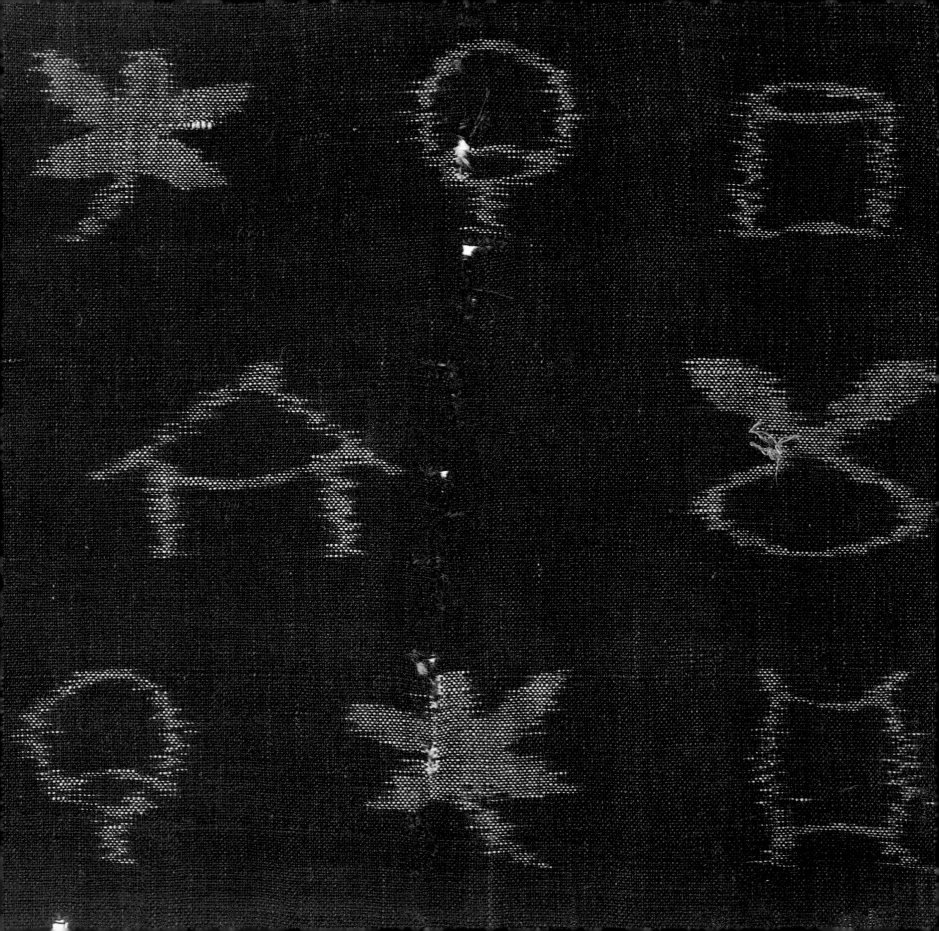

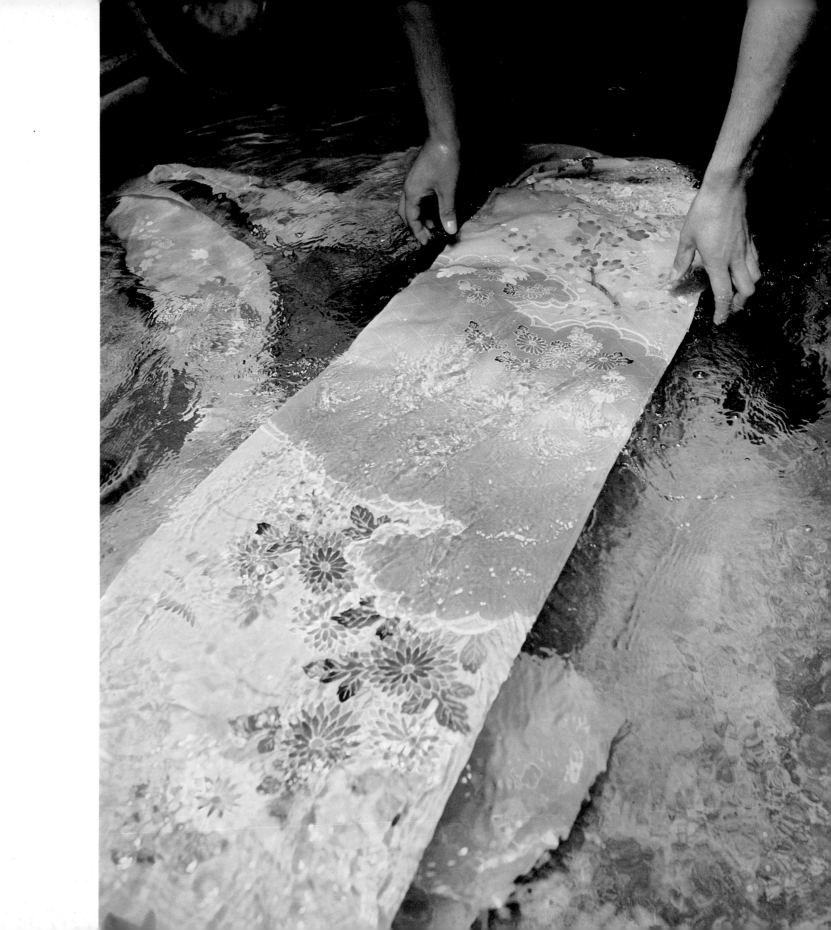

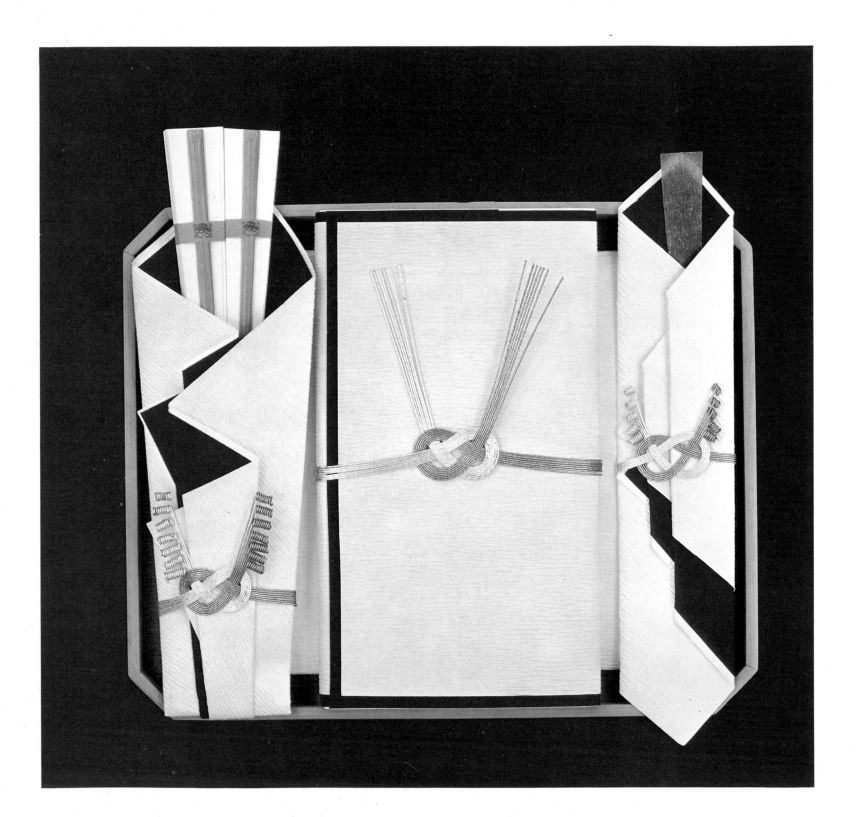

ELEGANCE

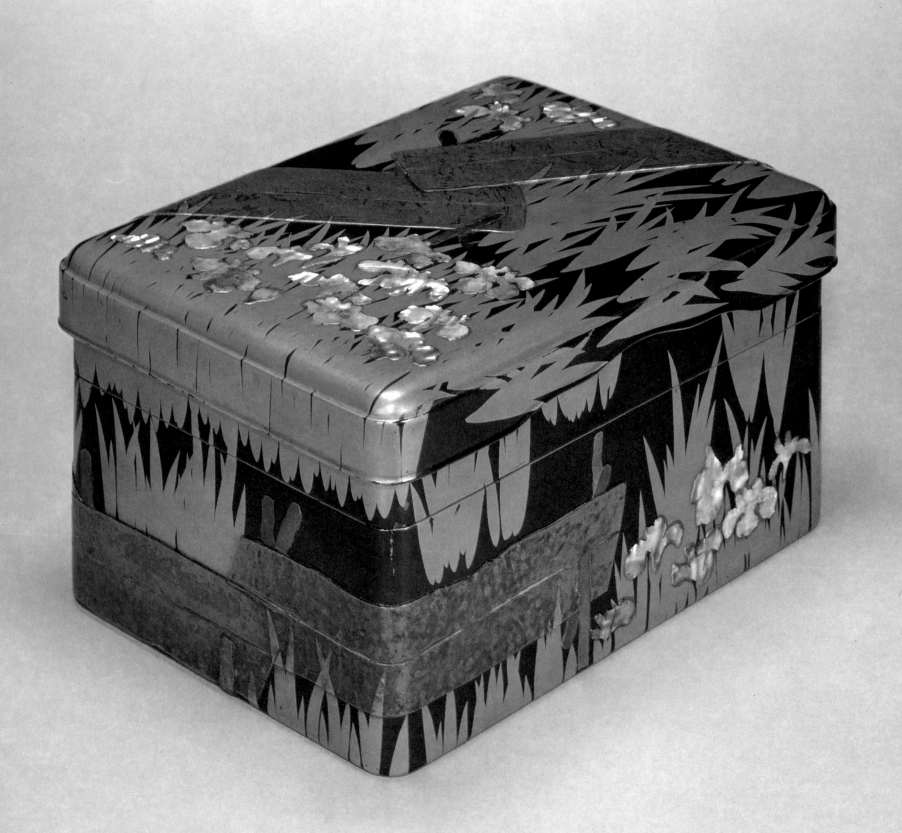

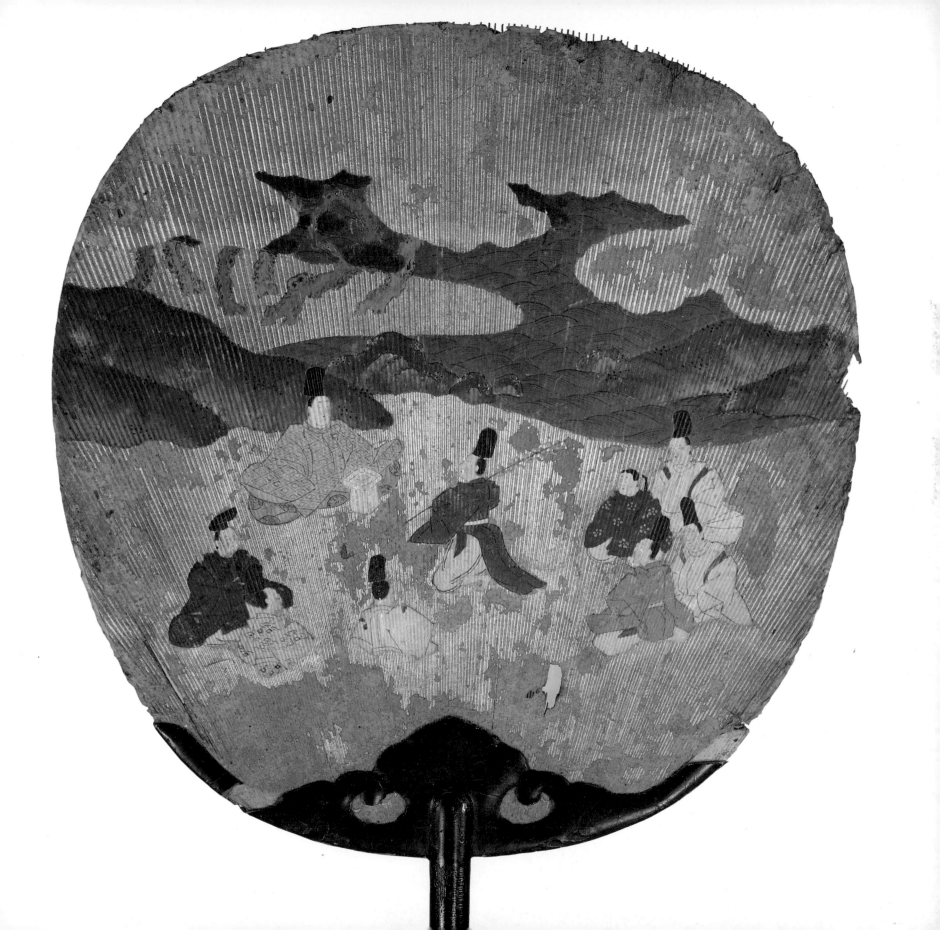

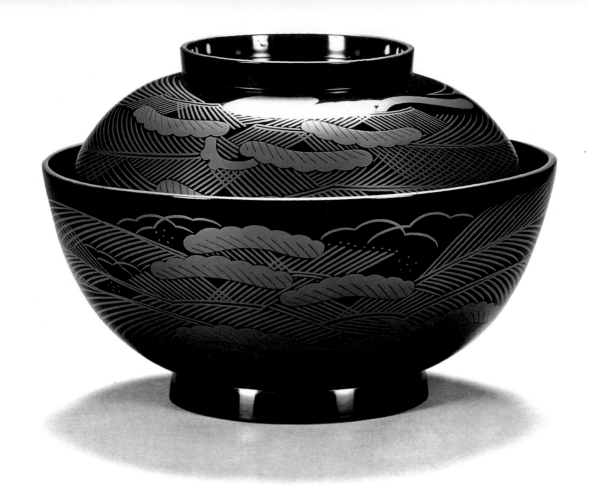

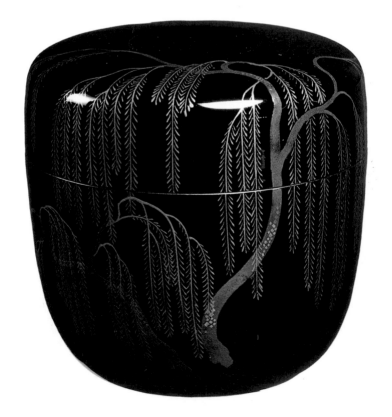

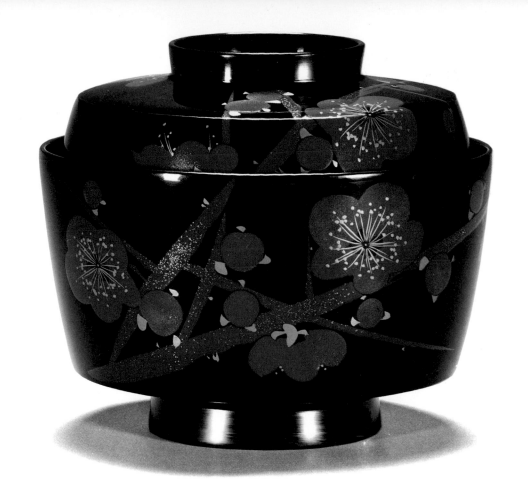

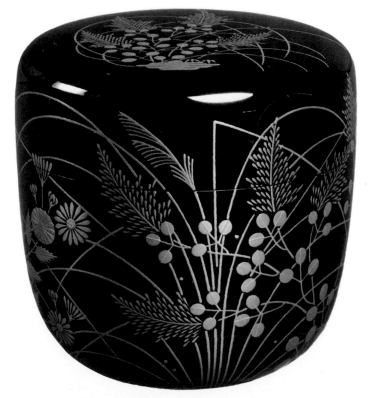

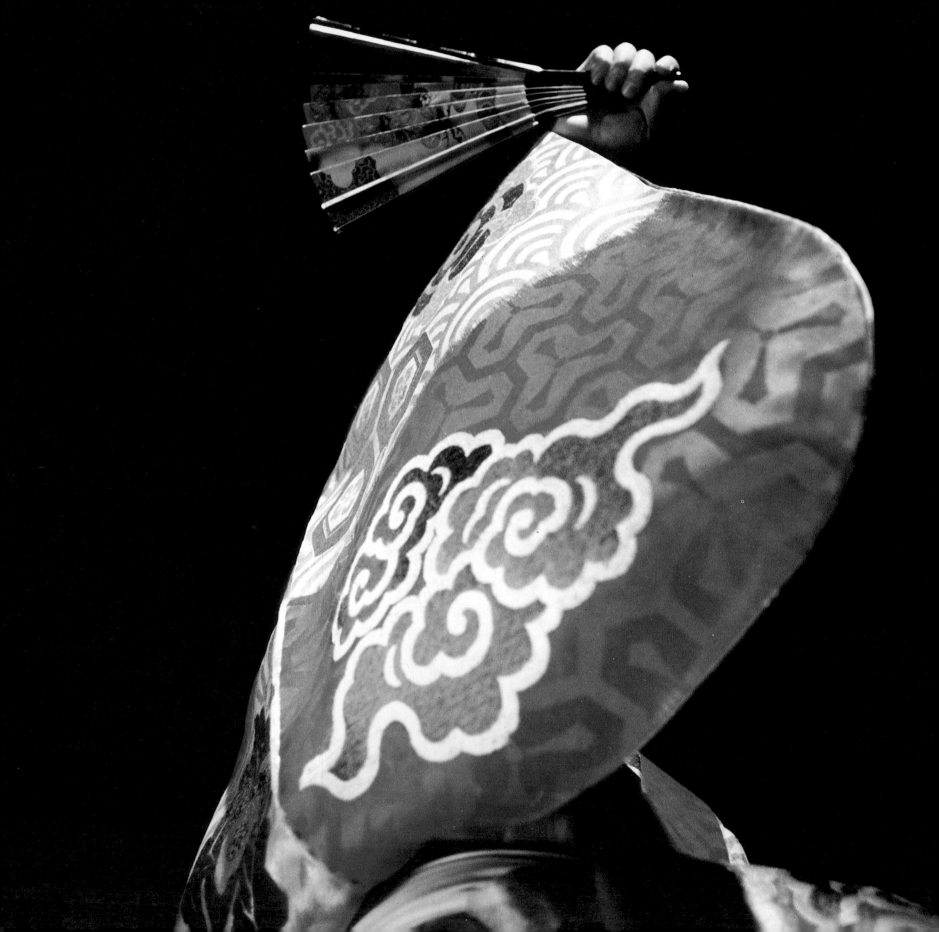

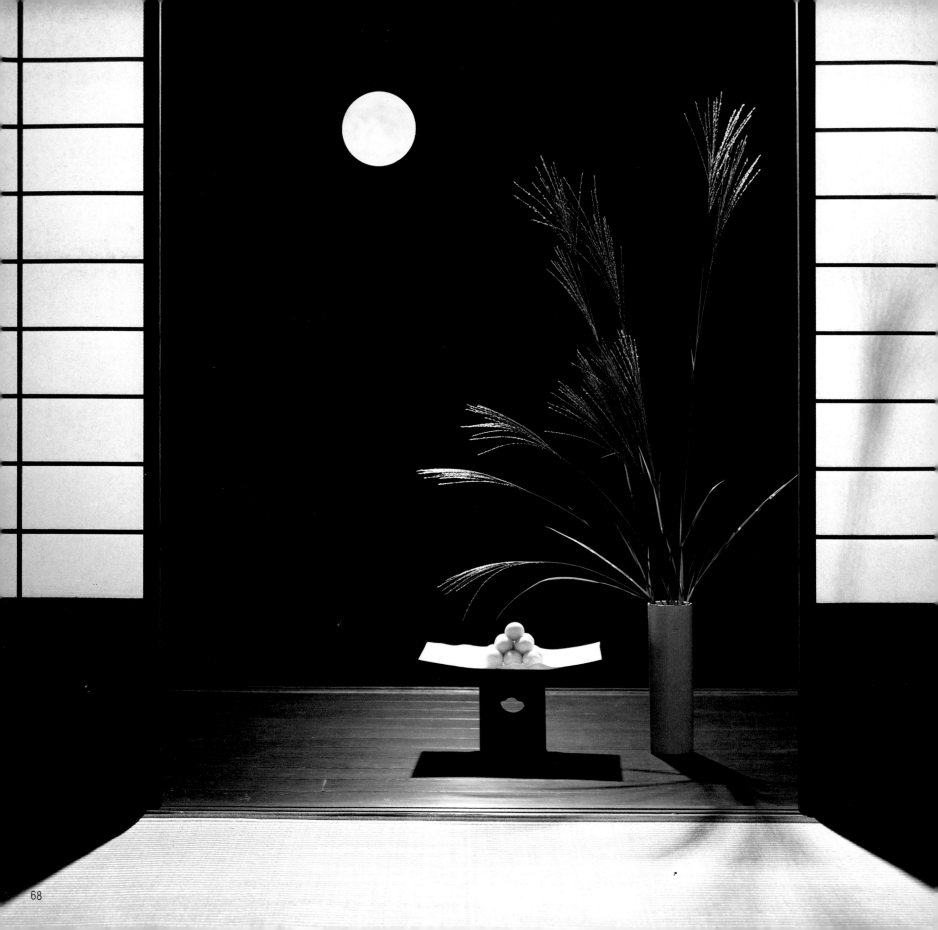

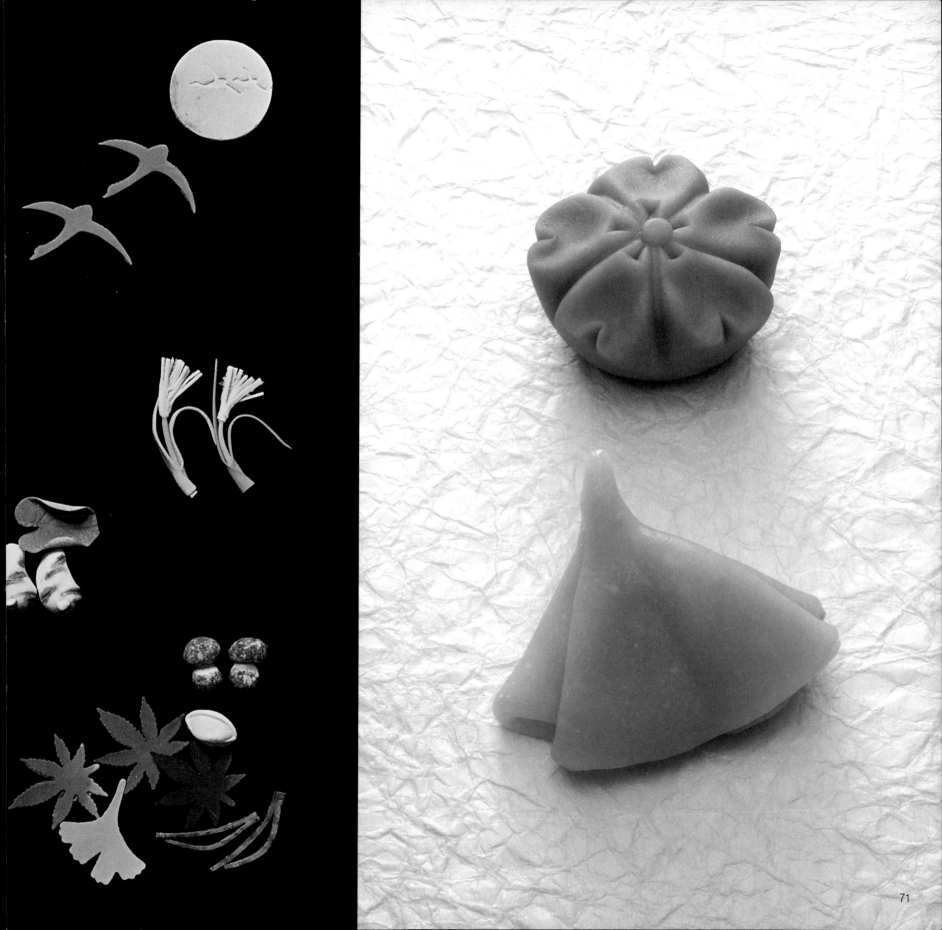

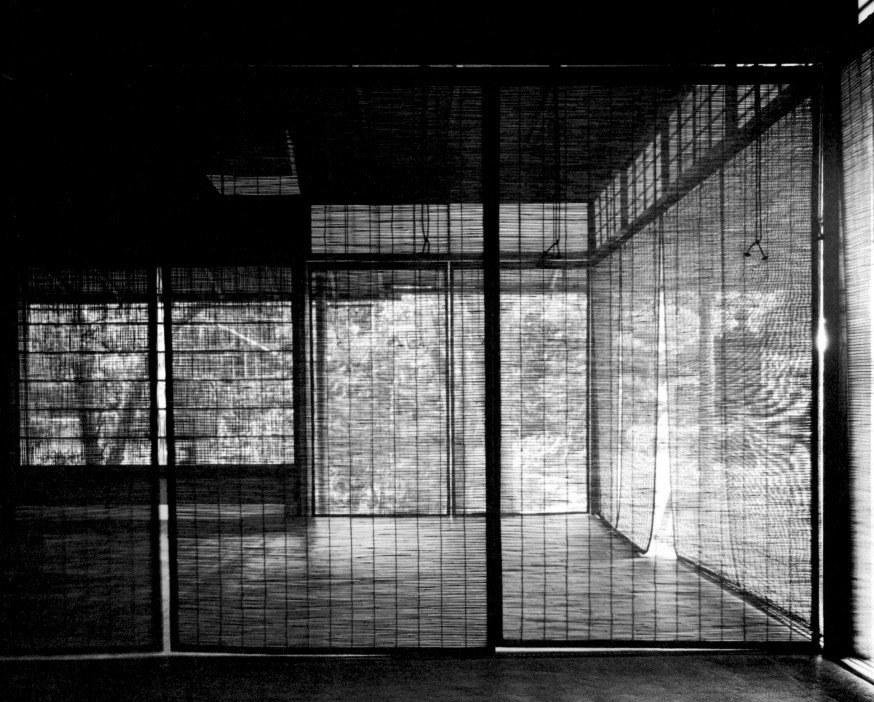

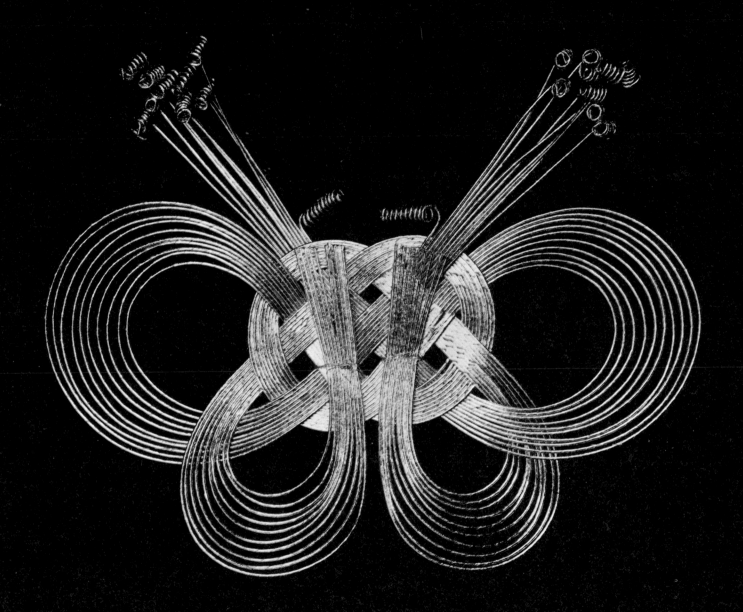

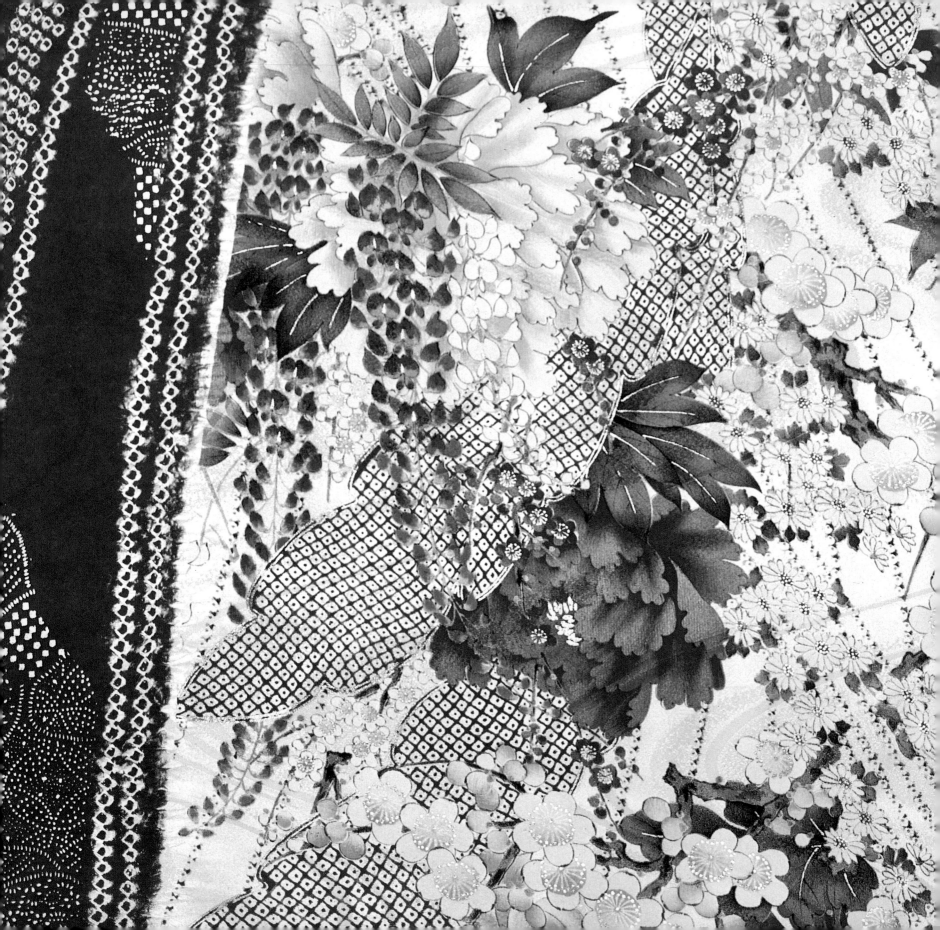

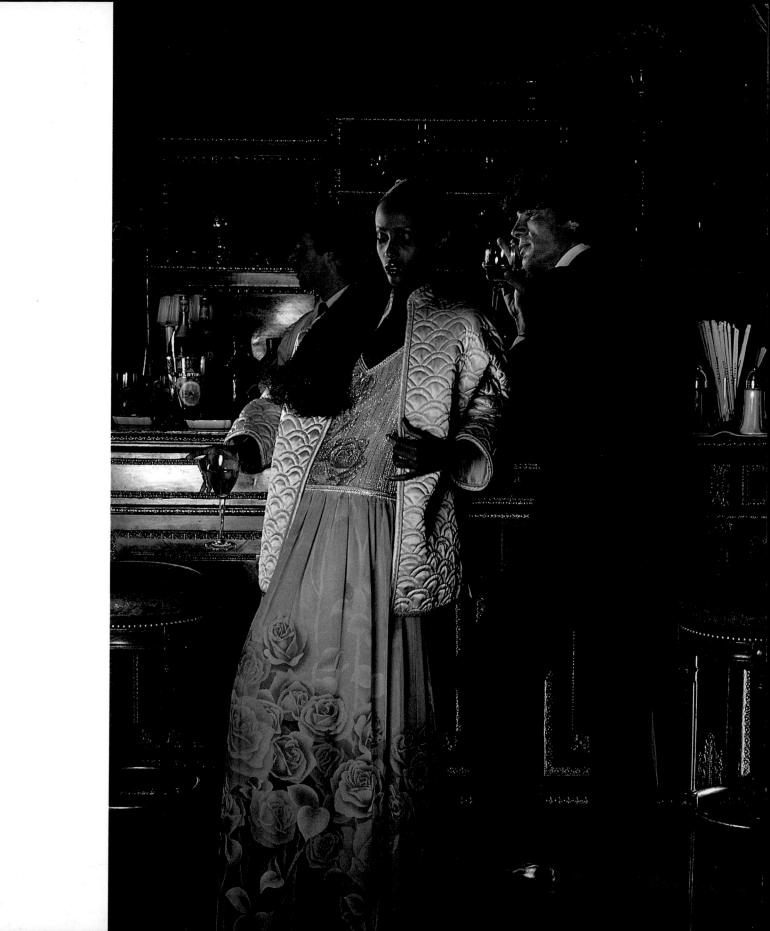

SIMPLICITY

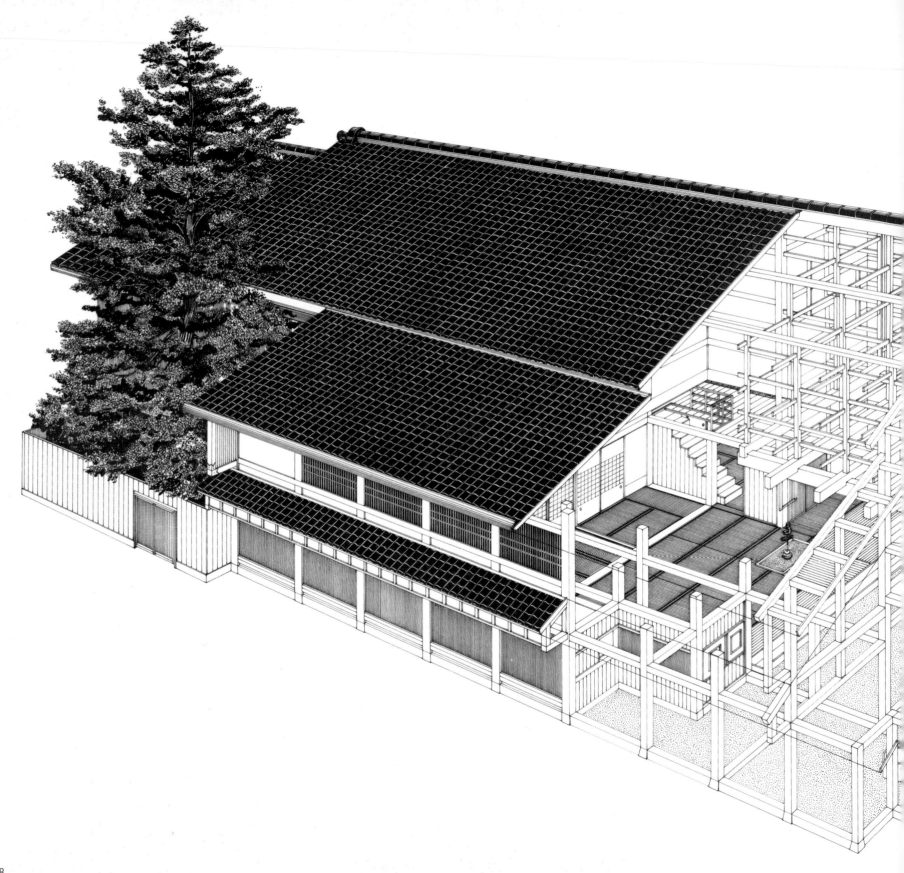

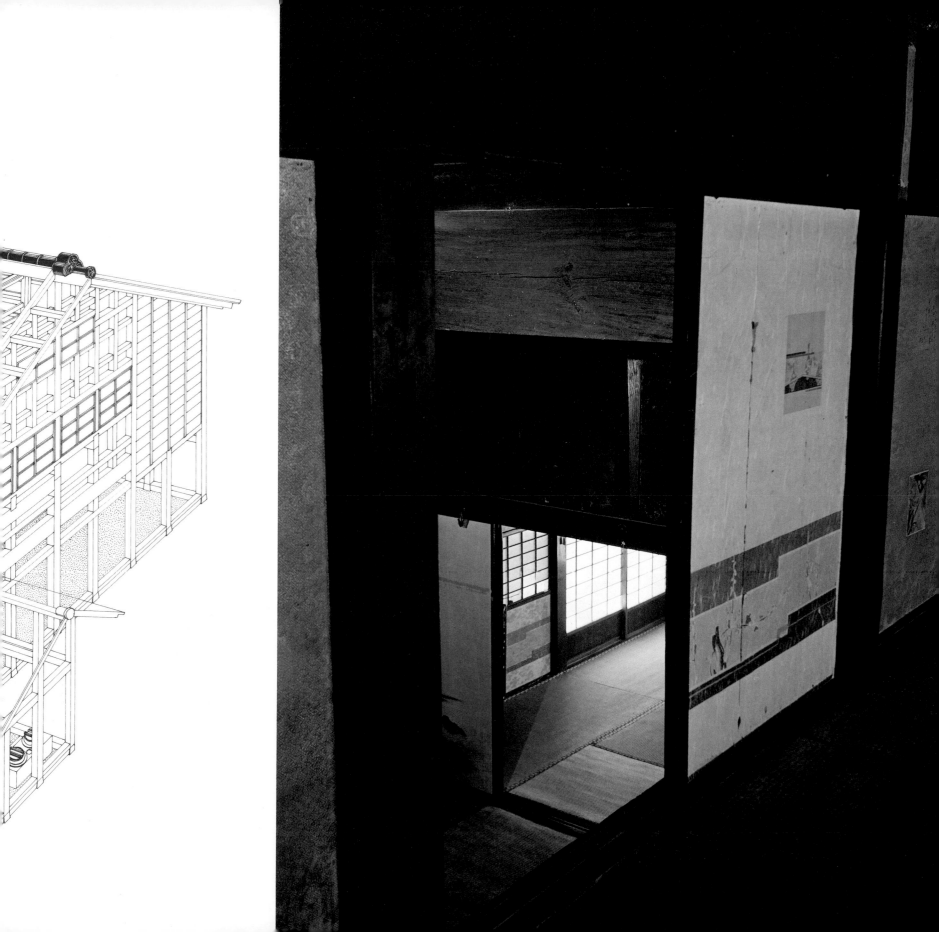

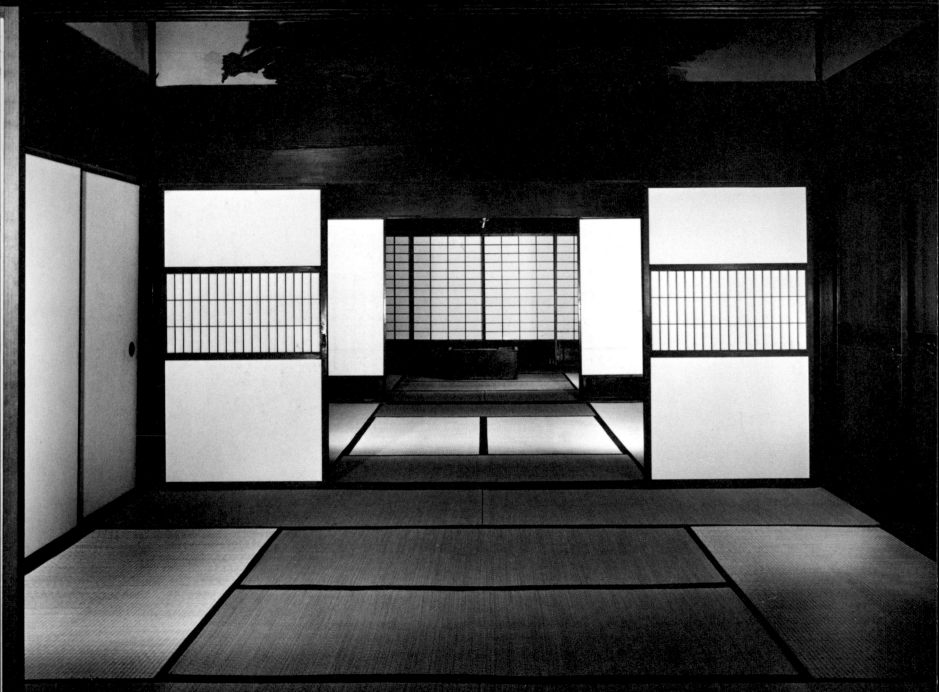

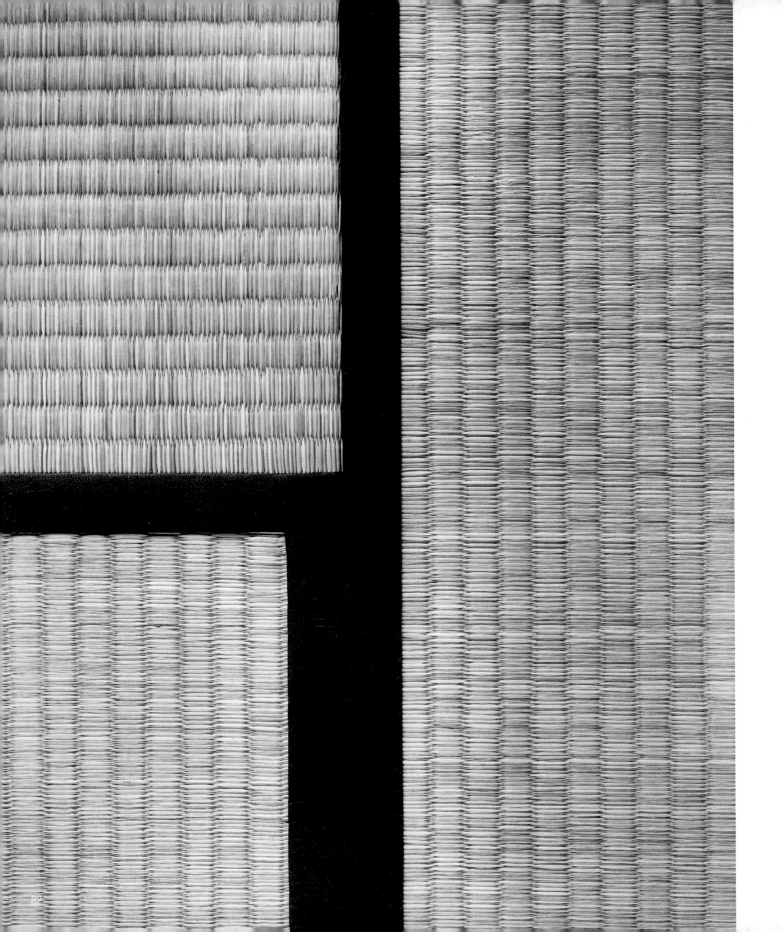

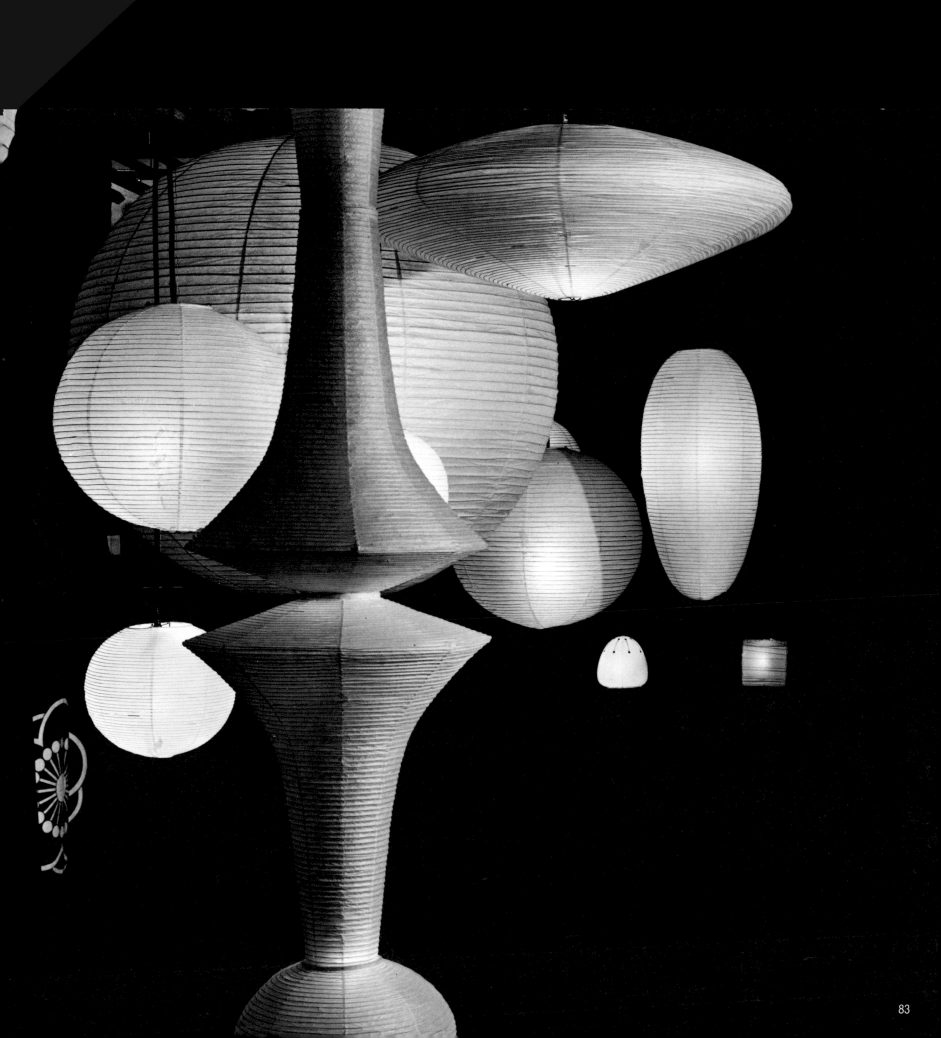

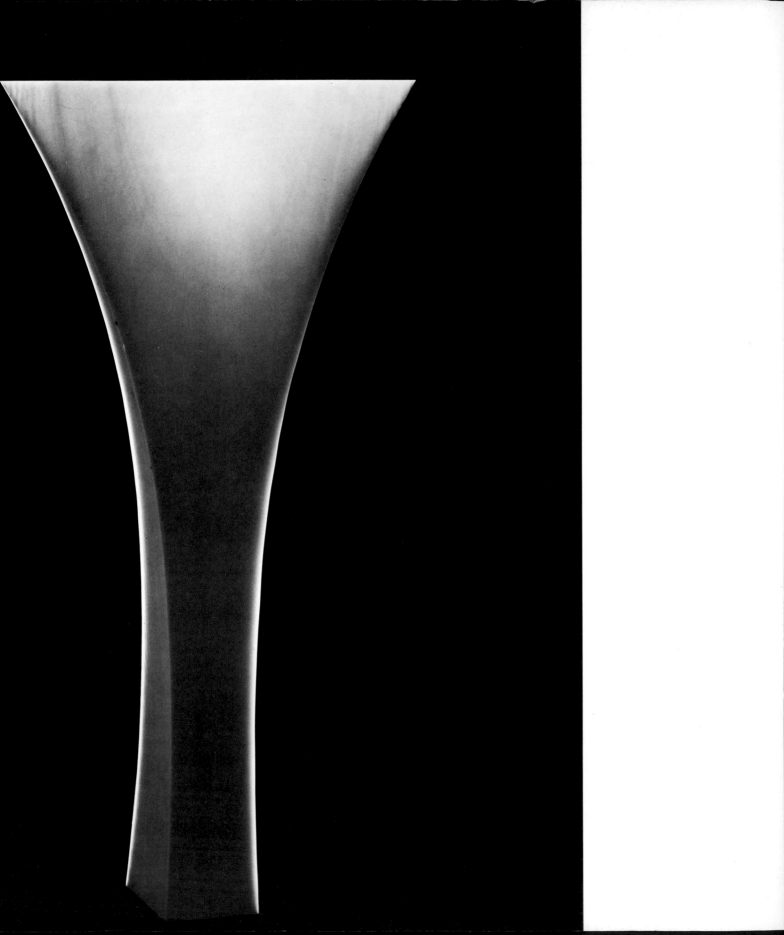

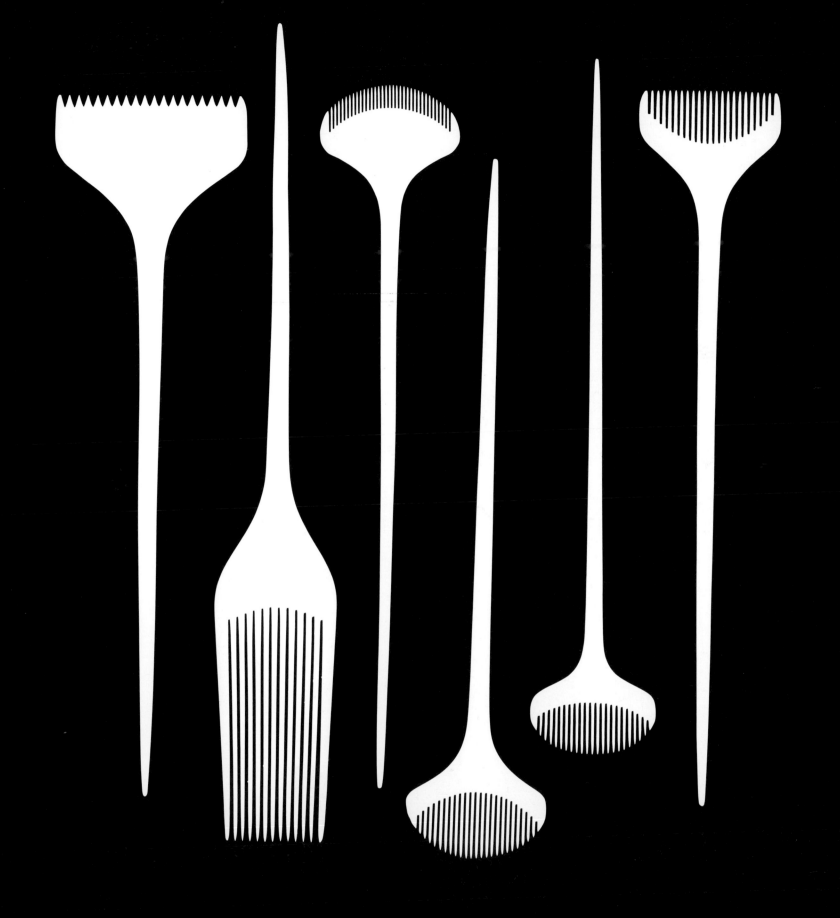

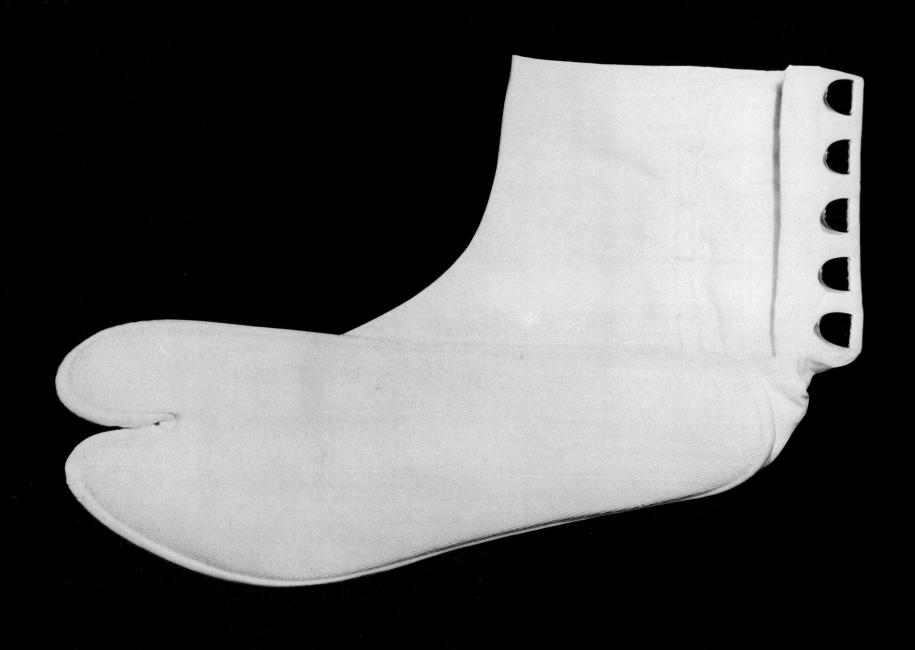

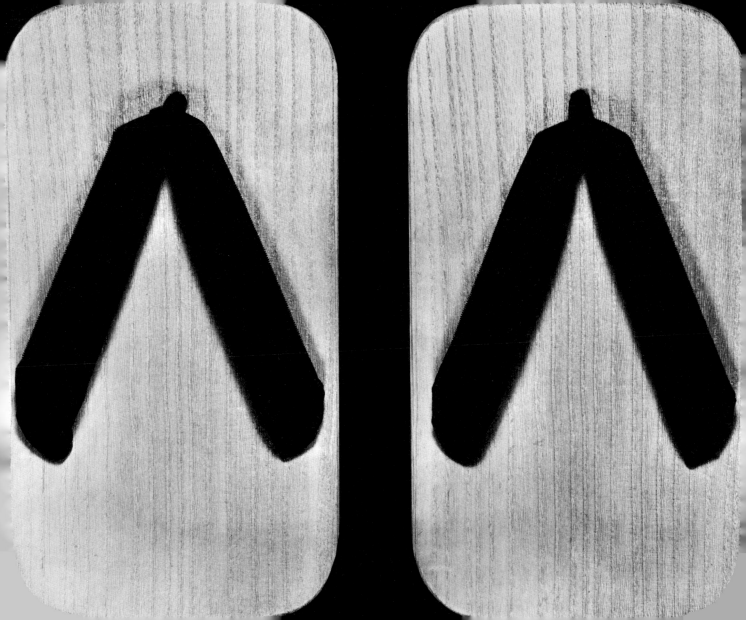

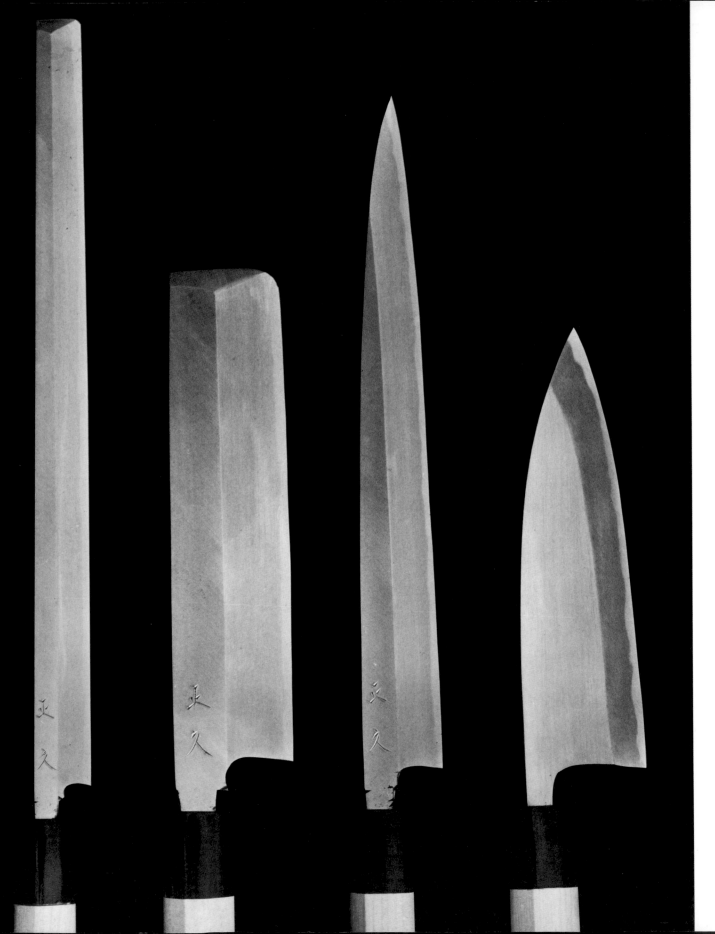

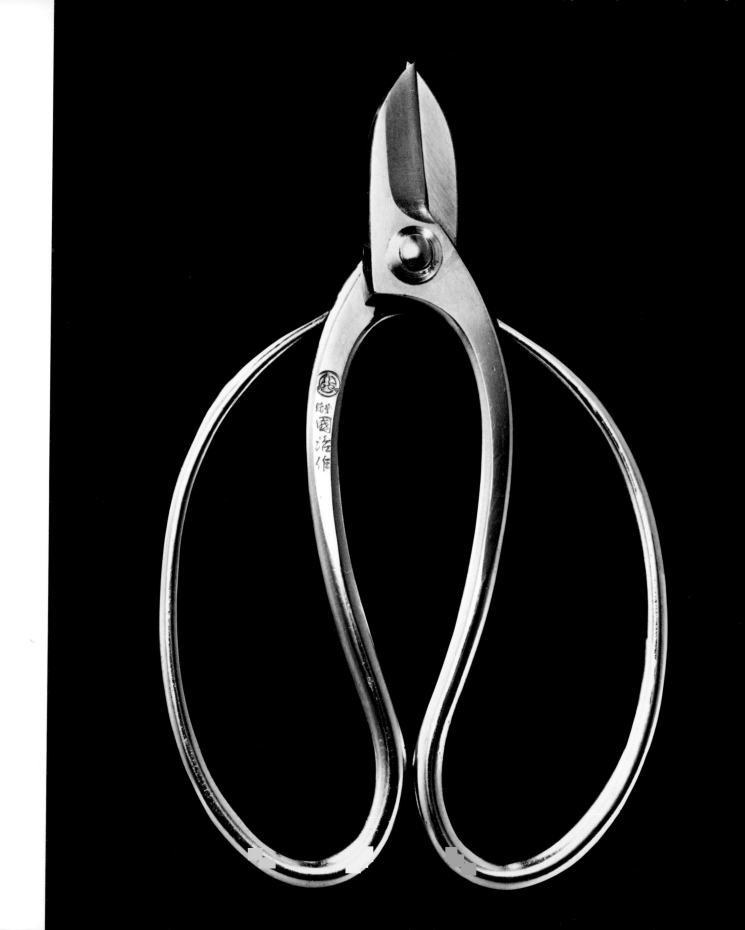

COMPACTNESS

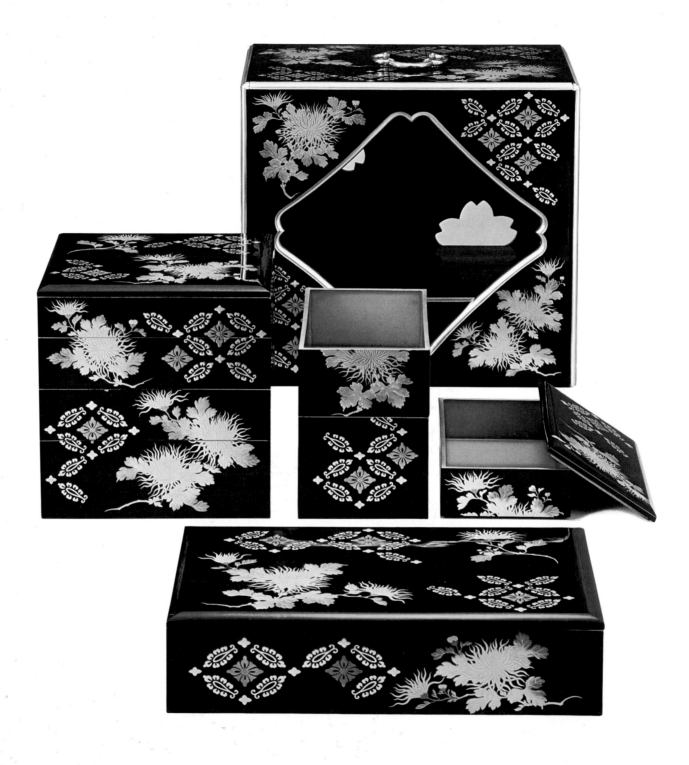

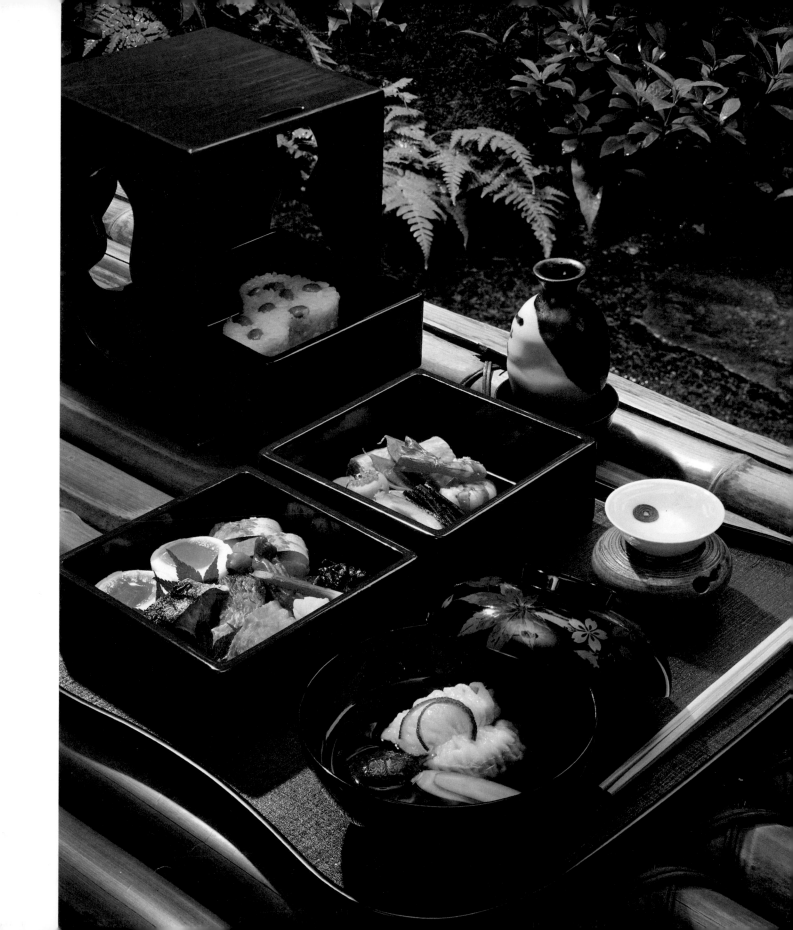

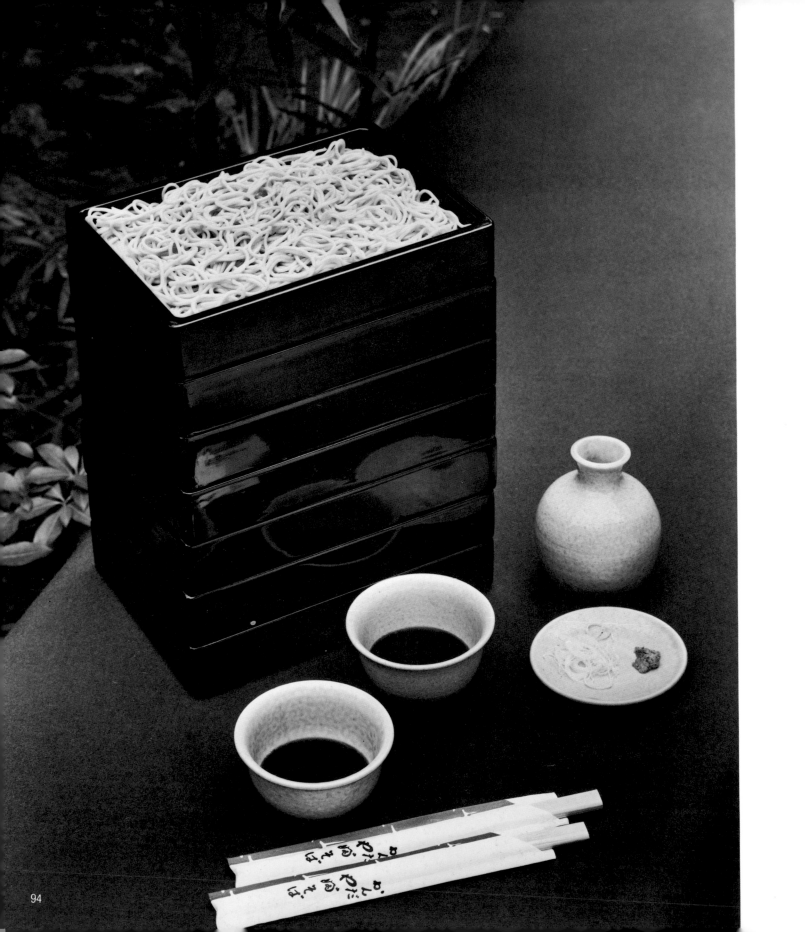

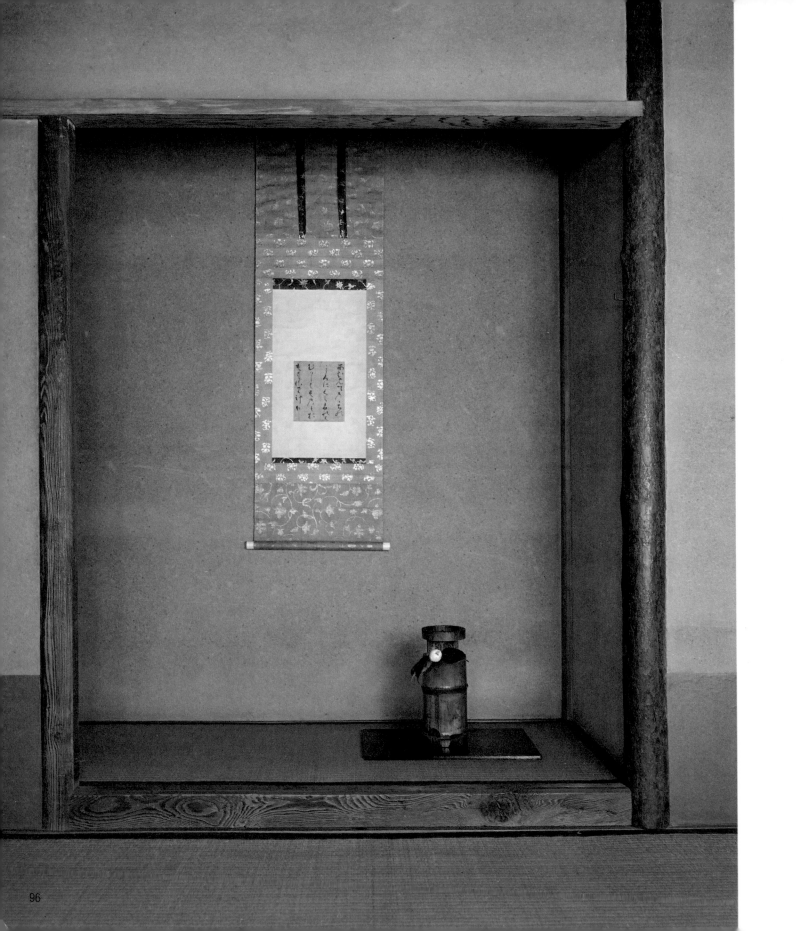

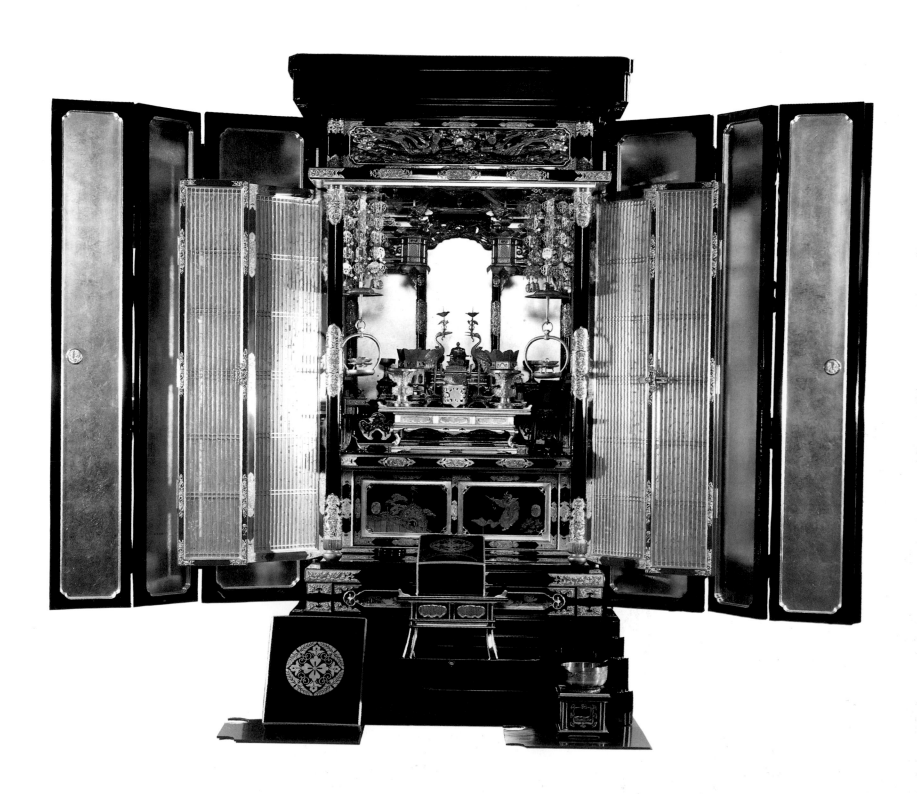

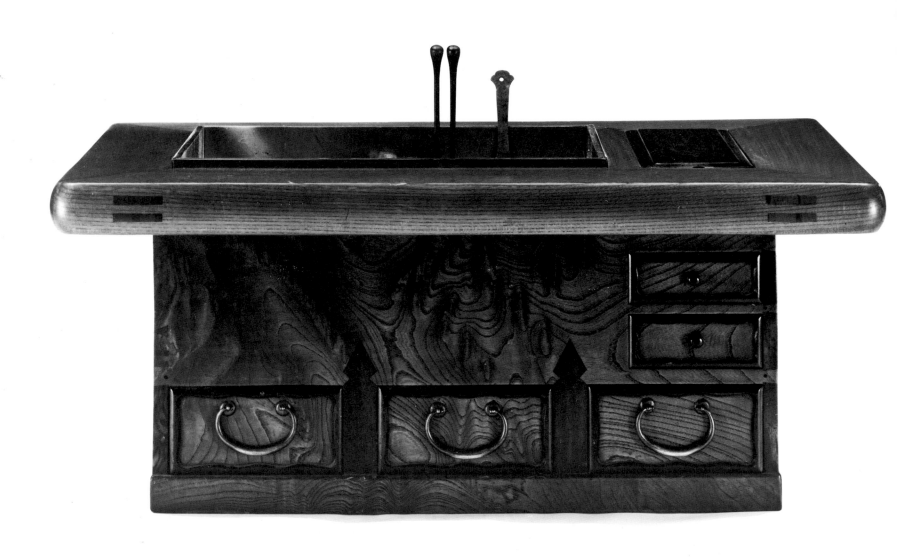

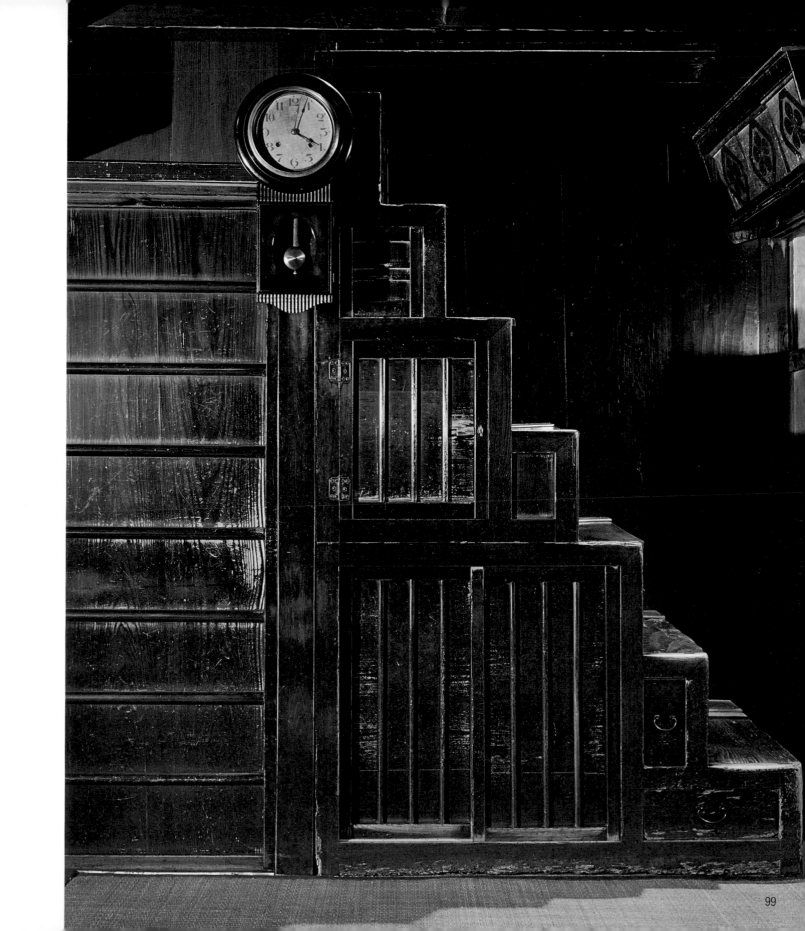

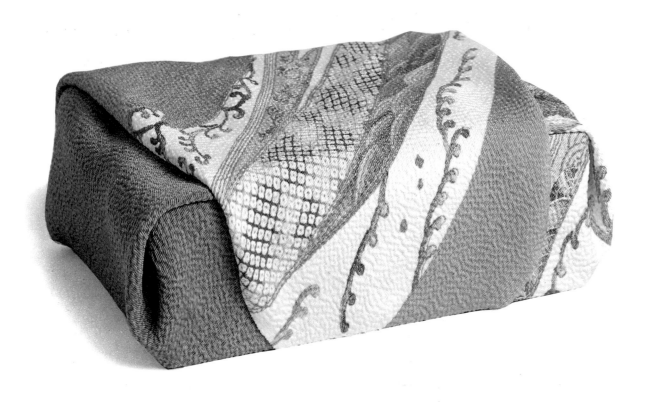

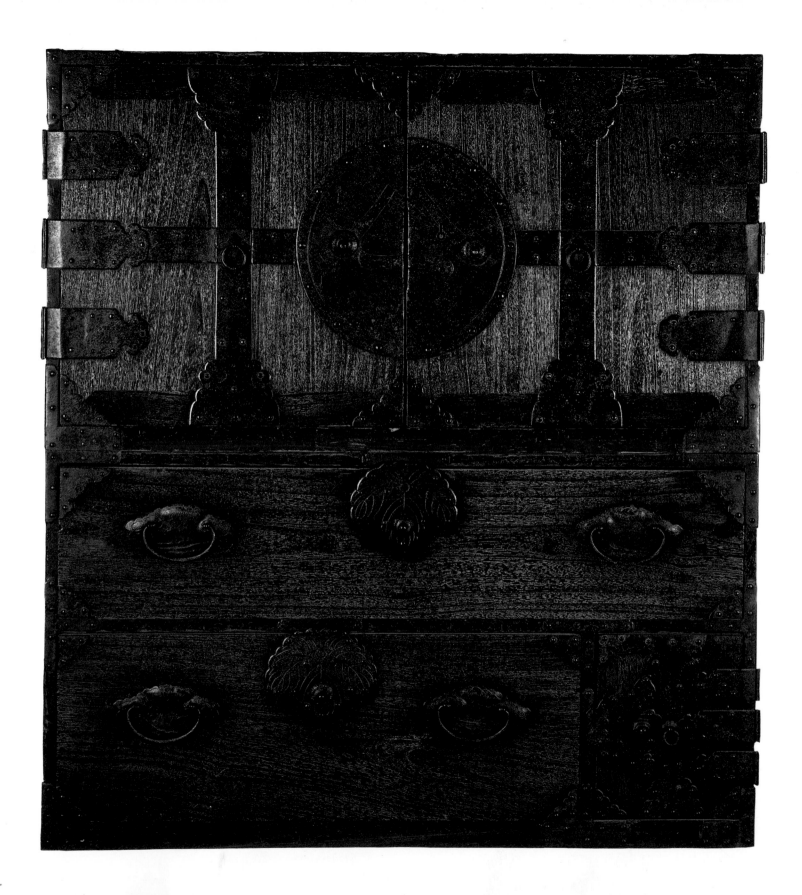

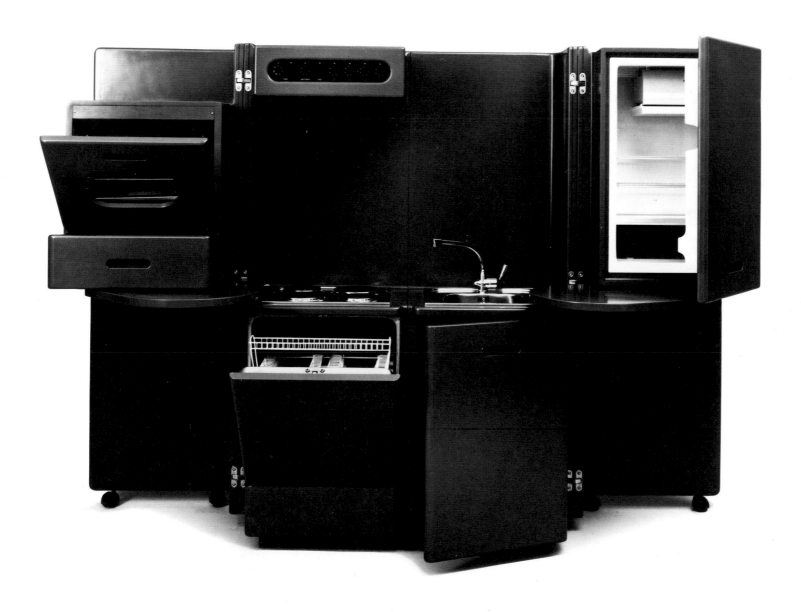

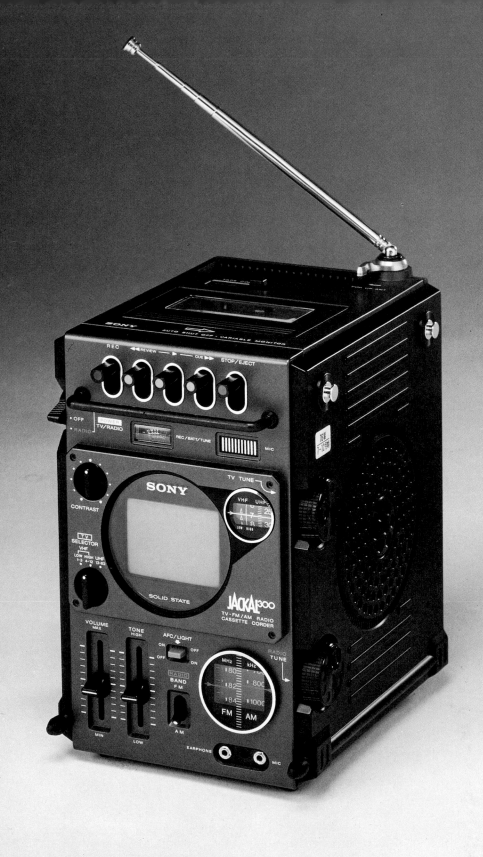

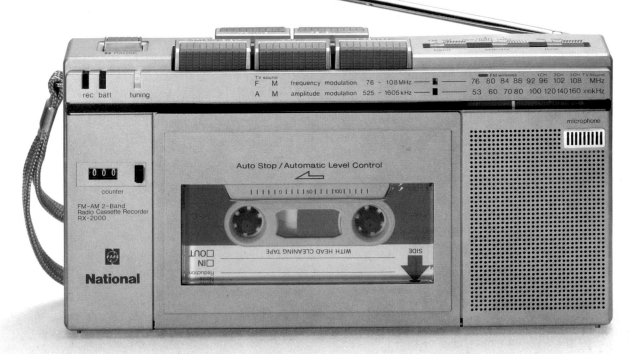

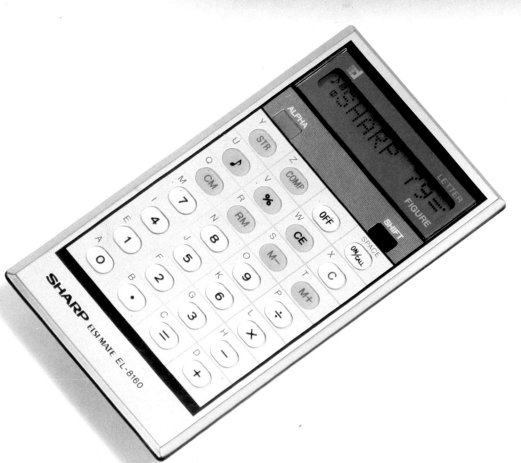

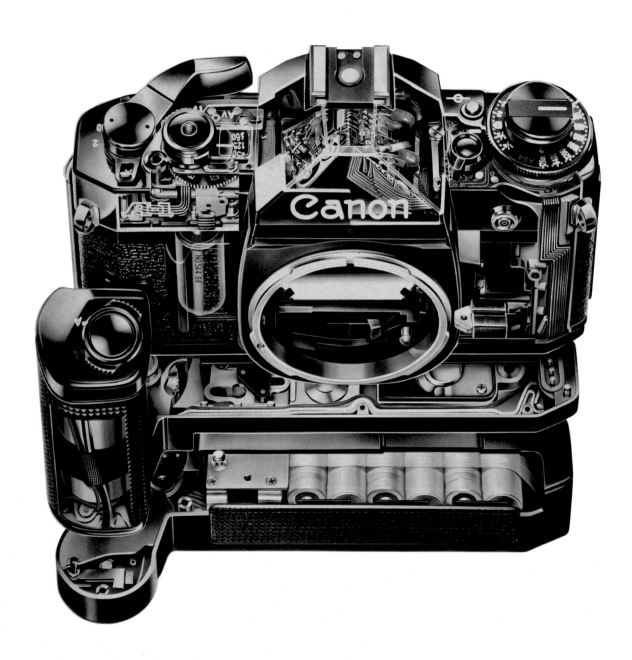

GRAPHISM

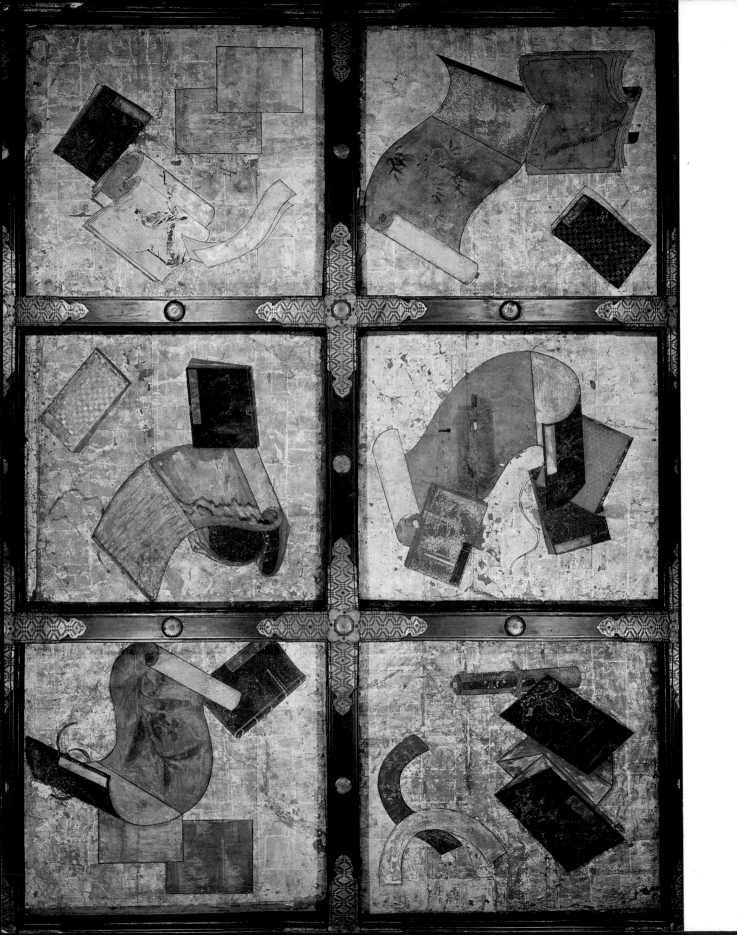

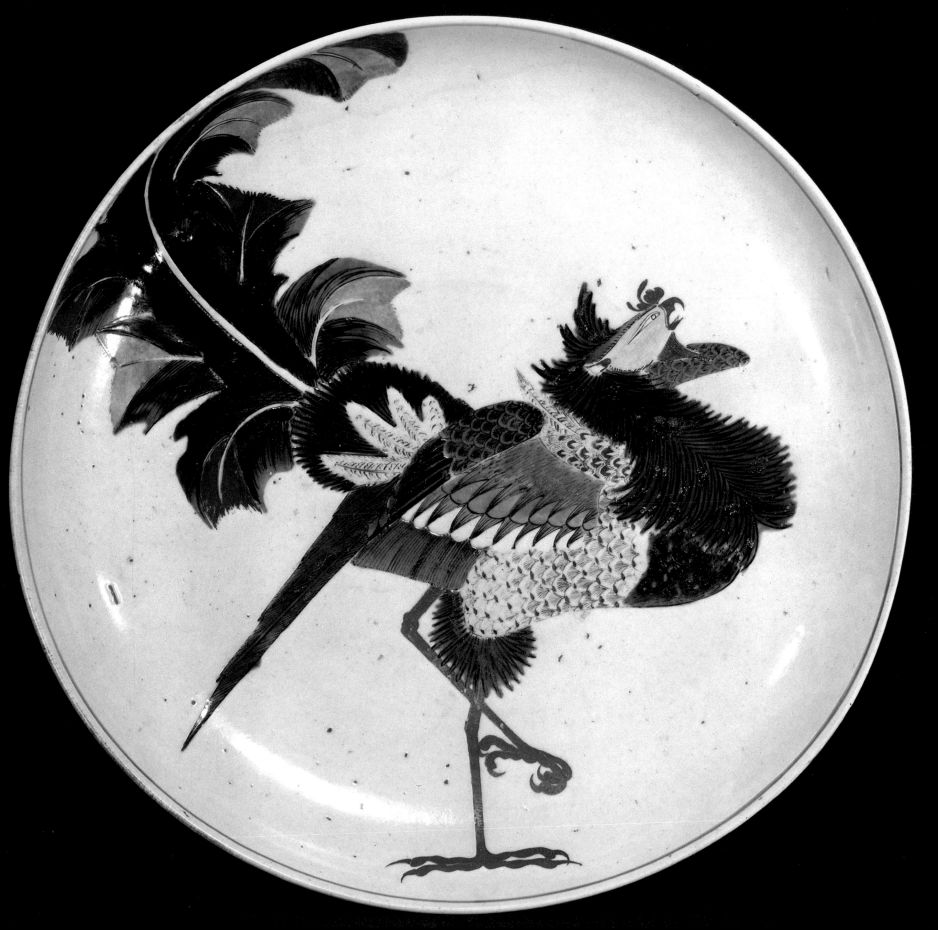

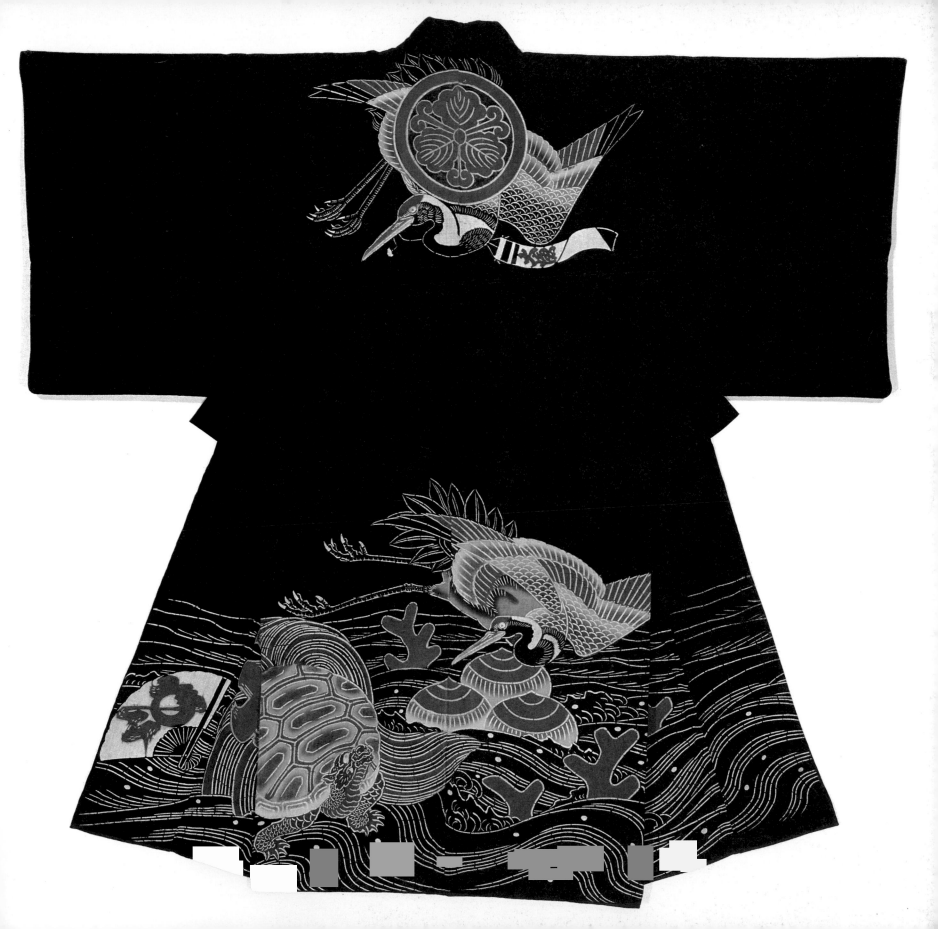

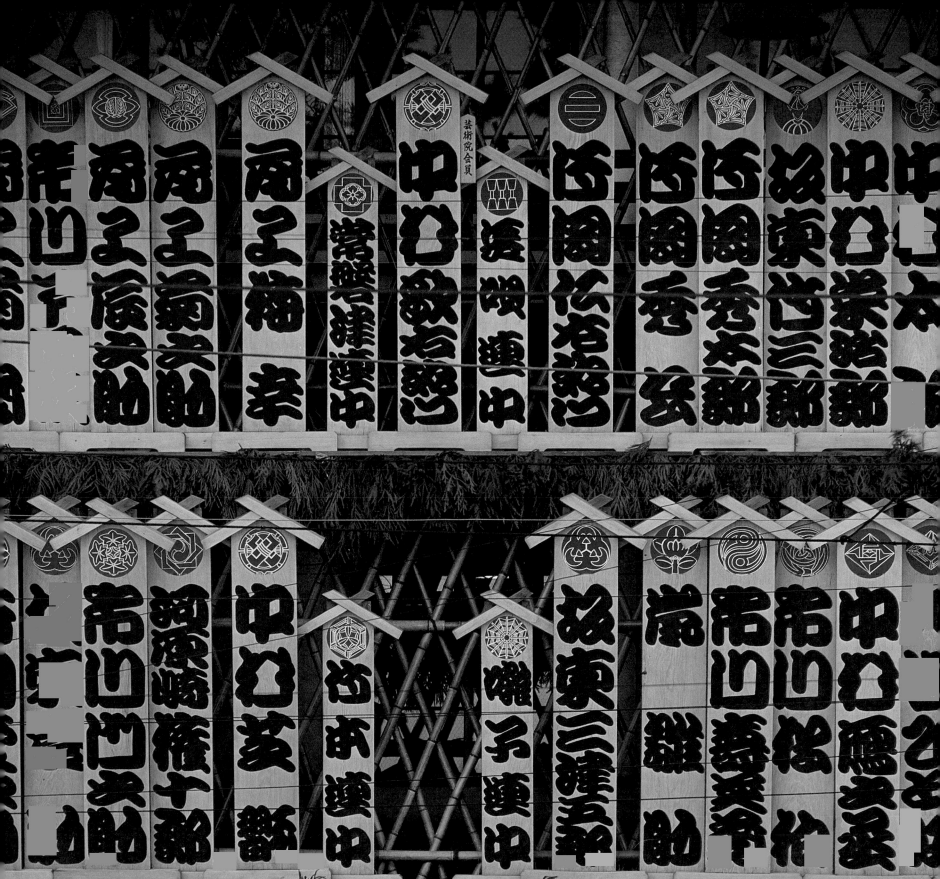

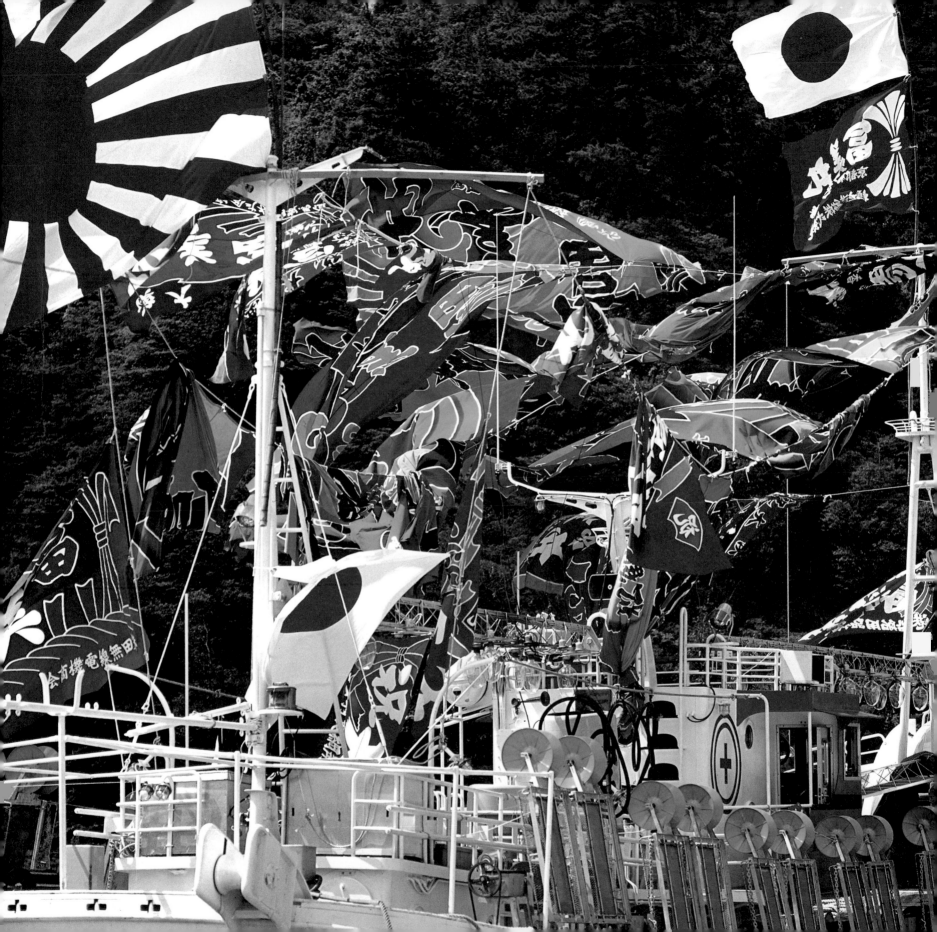

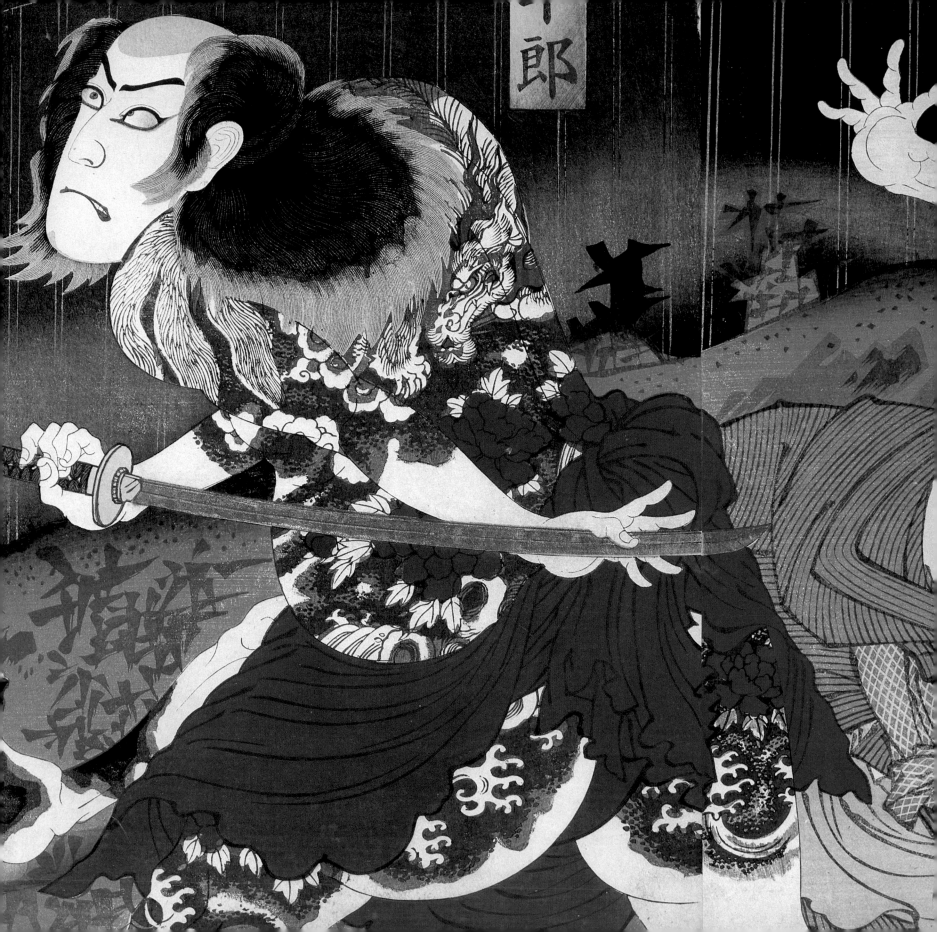

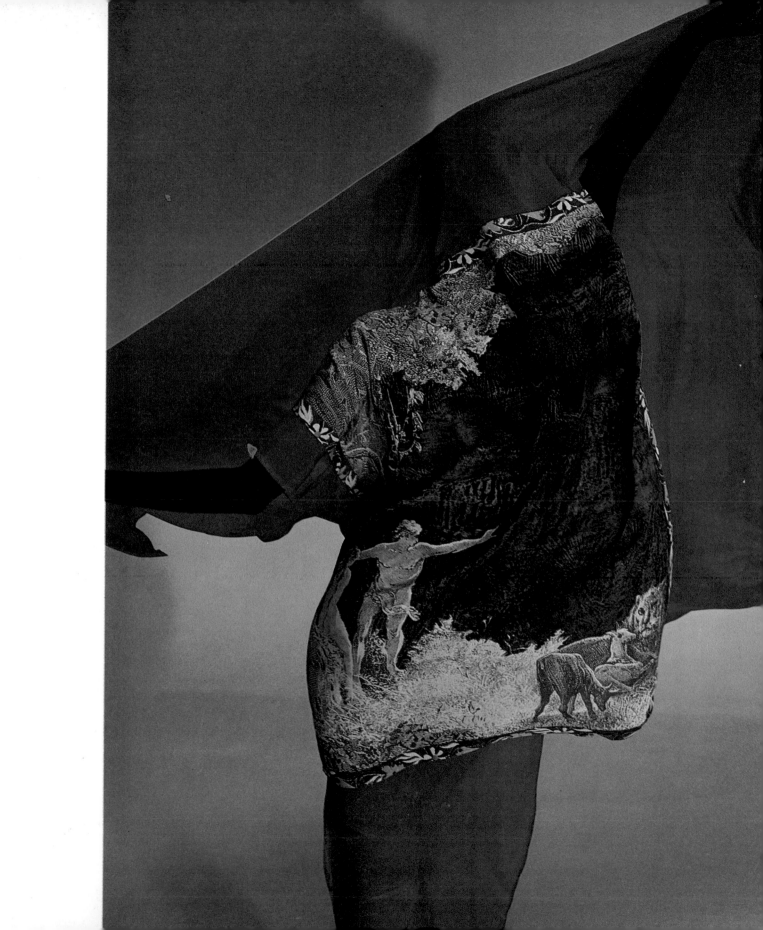

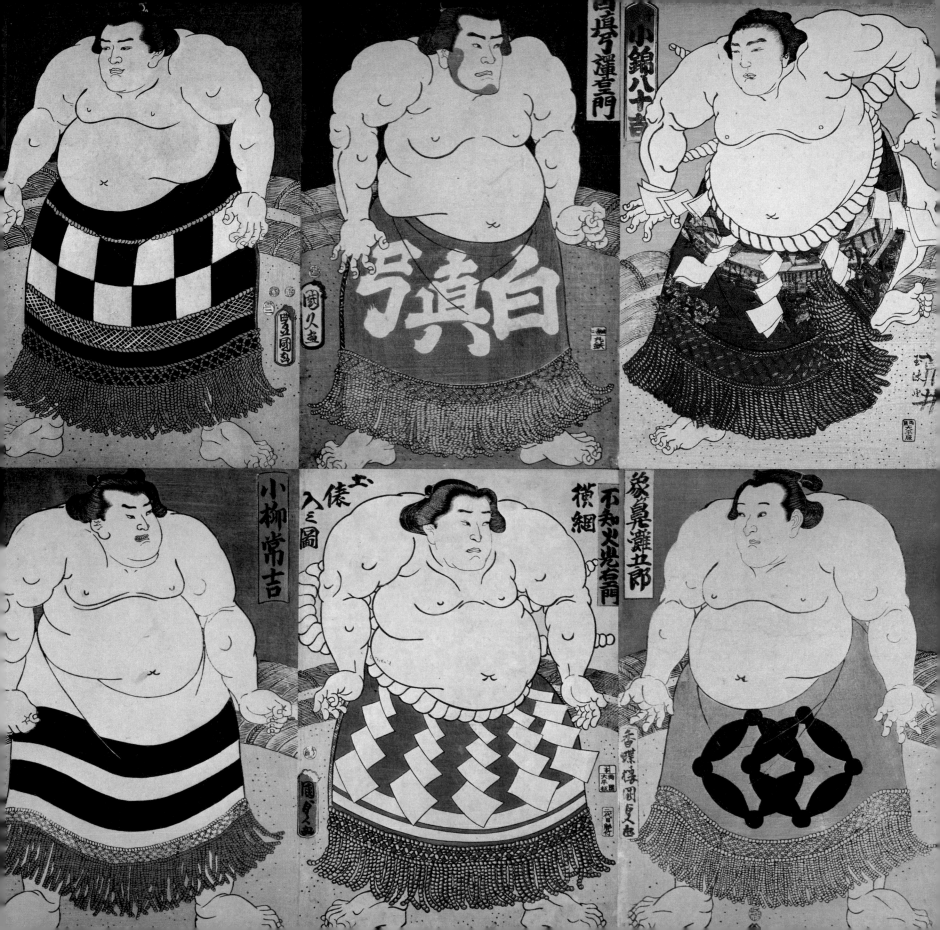

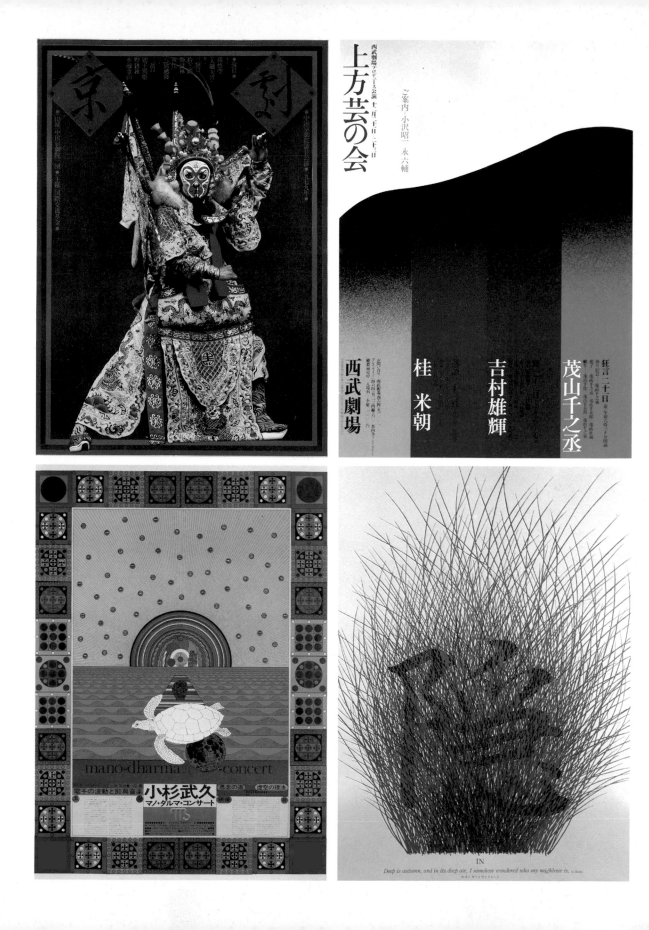

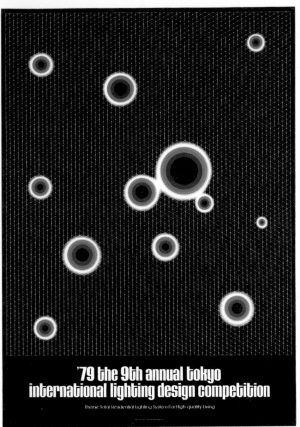

'79 the 9th annual tokyo
international lighting design competition

Theme: Total Residential Lighting System For High-quality Living

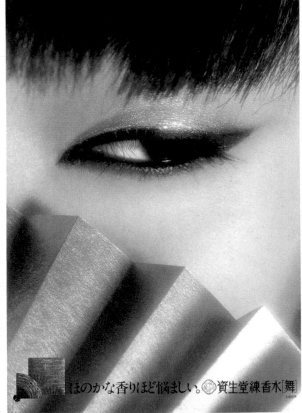

ほのかな香りほど悩ましい。◎資生堂練香水［舞］

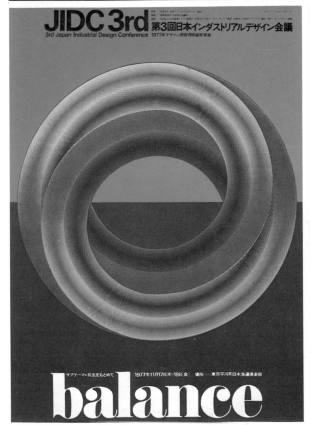

JIDC 3rd 第3回日本インダストリアルデザイン会議
3rd Japan Industrial Design Conference 1977年デザイン振興関連事業

balance

サブテーマ・共生をもとめて 1977年11月17日〔木〕・18日〔金〕 場所——東京平河町日本海運倶楽部

VITALITY

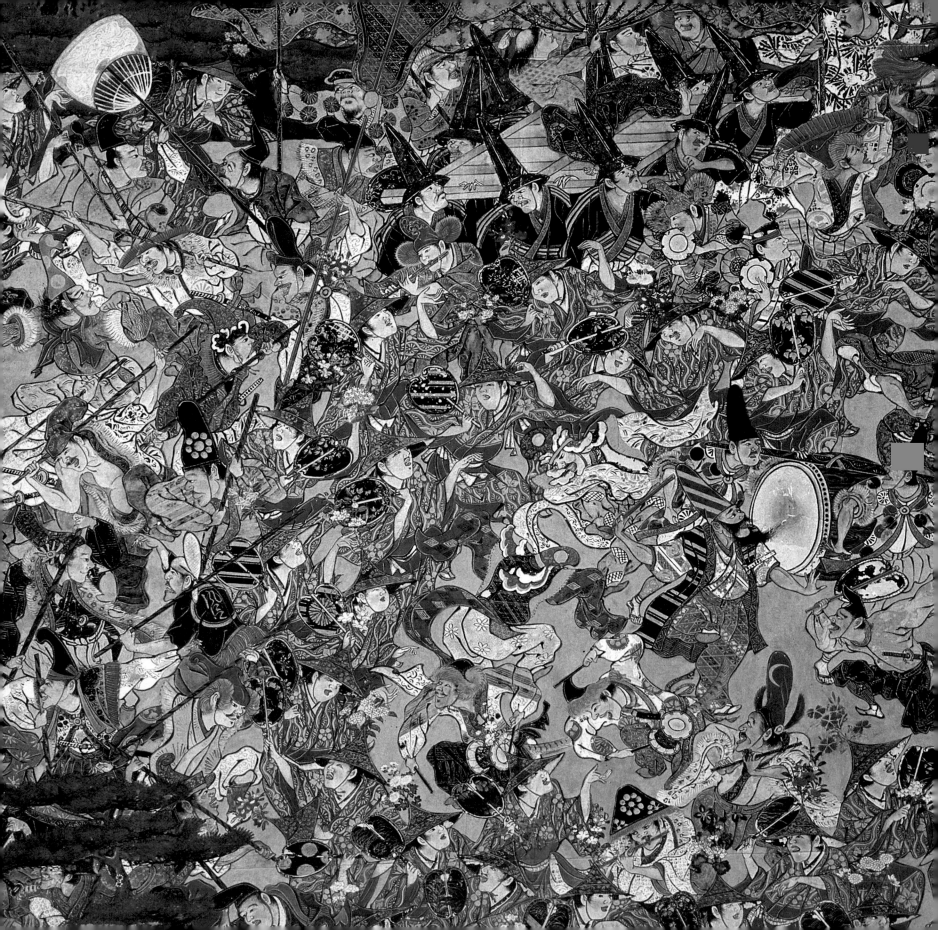

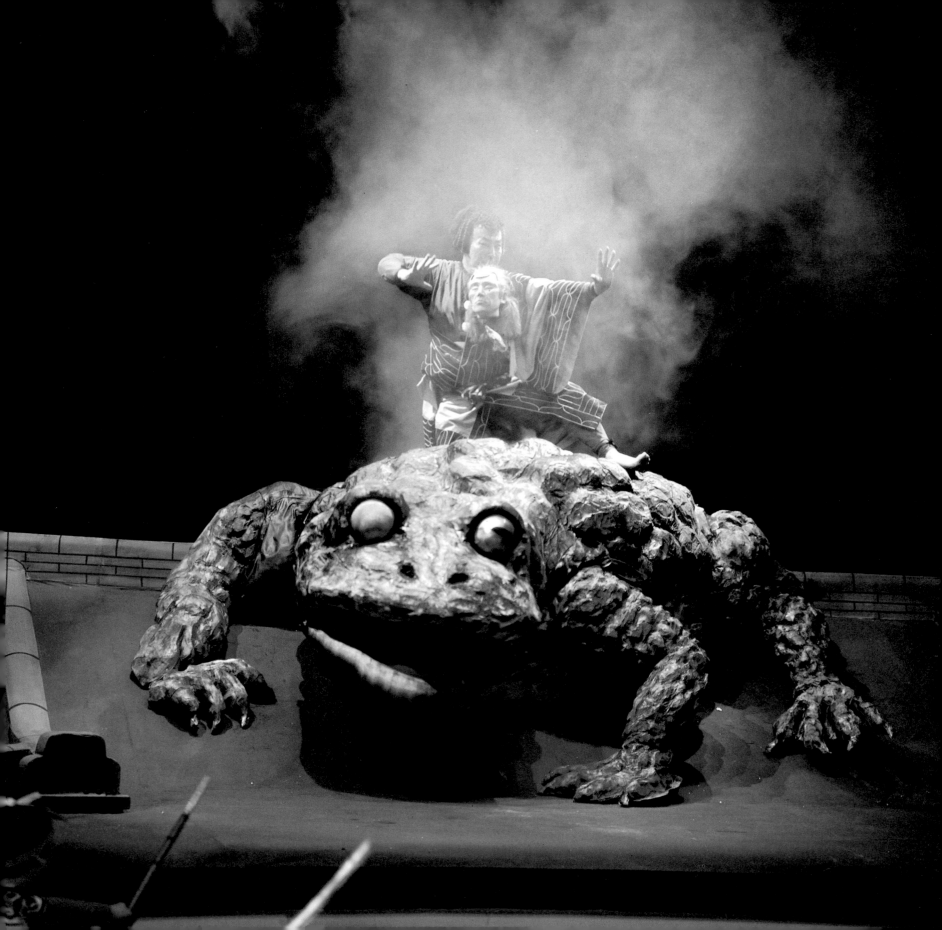

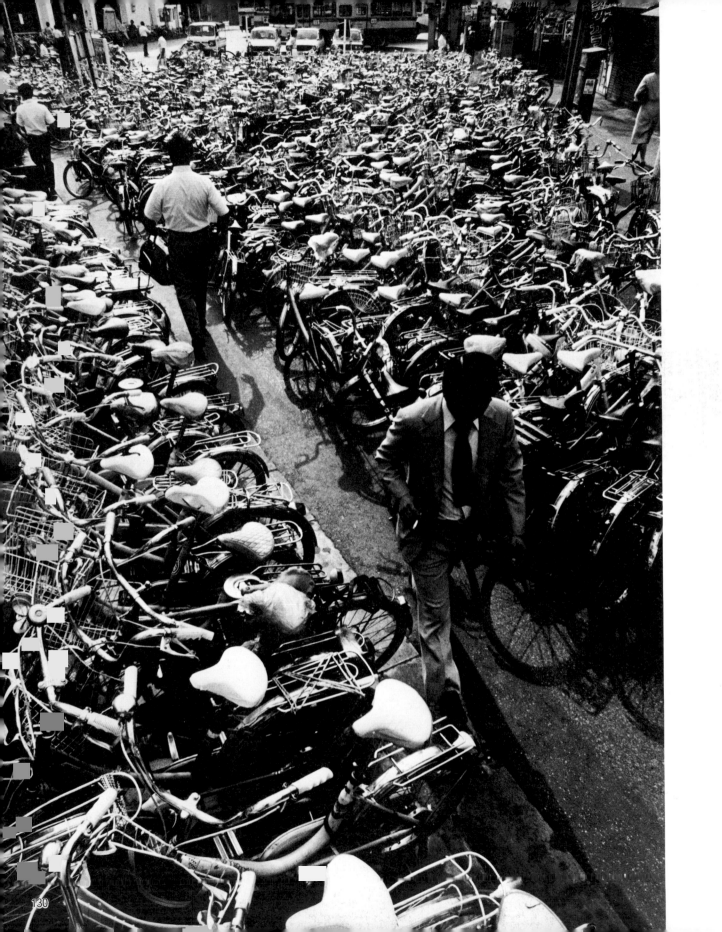

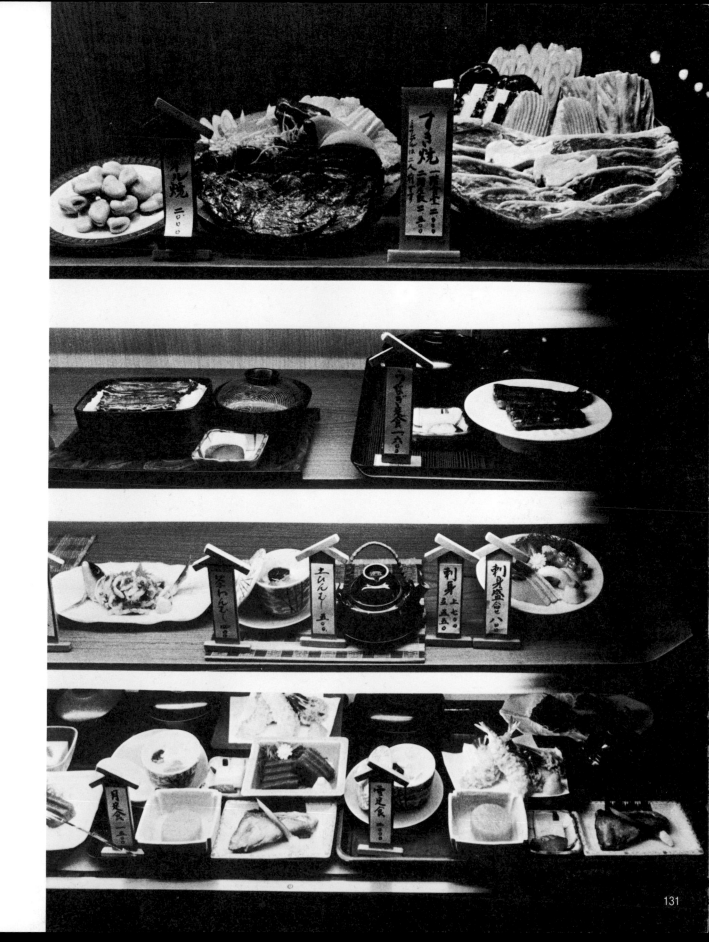

イノセント

L'INNOCENTE

A FILM BY LUCHINO VISCONTI

ルキノ・ヴィスコンティ監督作品

愛は選ぶことができるか？
映画芸術最大の巨匠が生涯の力を傾けて
苦悩する世界に贈る哀切なる遺言

出演：ジャンカルロ・ジャンニーニ
GIANCARLO GIANNINI
ラウラ・アントネリ
LAURA ANTONELLI
ジェニファー・オニール
JENNIFER O'NEILL
マルタ・ポレル
MARC POREL
マリー・デュボワ
MARIE DUBOIS
ディナ・セレ
RINA MORELLI
マッシモ・ジロッティ
MASSIMO GIROTTI
ディディエ・オードパン
DIDIER HAUDEPIN
ロベルタ・パラディーニ
ROBERTA PALADINI
クロード・マン
CLAUDE MANN
監督：ルキノ・ヴィスコンティ
DIRECTED BY LUCHINO VISCONTI
製作：ジョヴァンニ・ベルトルッチ
PRODUCED BY
GIOVANNI BERTOLUCCI
原作：ガブリエレ・ダンヌンツィオ
BASED ON GABRIELE D'ANNUNZIO
脚本：スーゾ・チェッキ・ダミーコ
SCREENPLAY BY
SUSO CECCHI D'AMICO
エンリコ・メディオーリ
ENRICO MEDIOLI
ルキノ・ヴィスコンティ
LUCHINO VISCONTI
撮影：パスクアリーノ・デ・サンティス
DIRECTOR OF PHOTOGRAPHY:
PASQUALINO DE SANTIS
美術：マリオ・ガルブグリア
ART DIRECTOR:
MARIO GARBUGLIA
音楽：フランコ・マンニーノ
MUSIC BY FRANCO MANNINO
衣裳：ピエロ・トージ
COSTUMES BY PIERO TOSI
イタリア映画／リッツォーリ・フィルム
RIZZOLI FILM-ITALY
シネマスコープ／テクニカラー作品
TECHNISCOLOR-CINEMASCOPE
サウンド盤／RCAレコード
SCREEN MUSIC BROUGHT BY
RCA RECORDS
原作ヘラルド出版刊
ORIGINAL NOVEL PUBLISHED BY
HERALD BOOKS

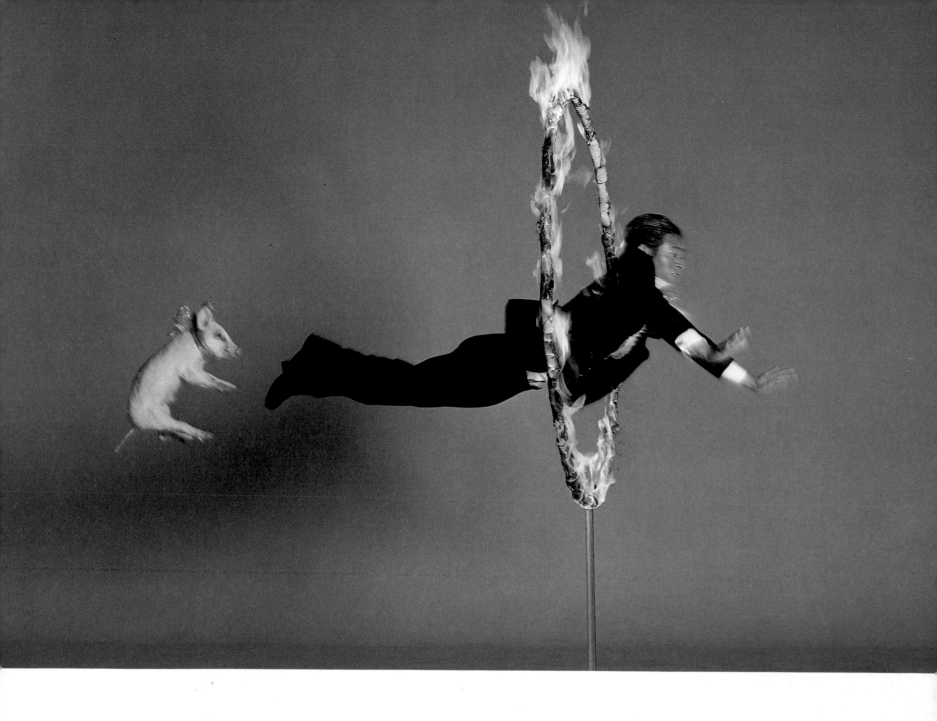

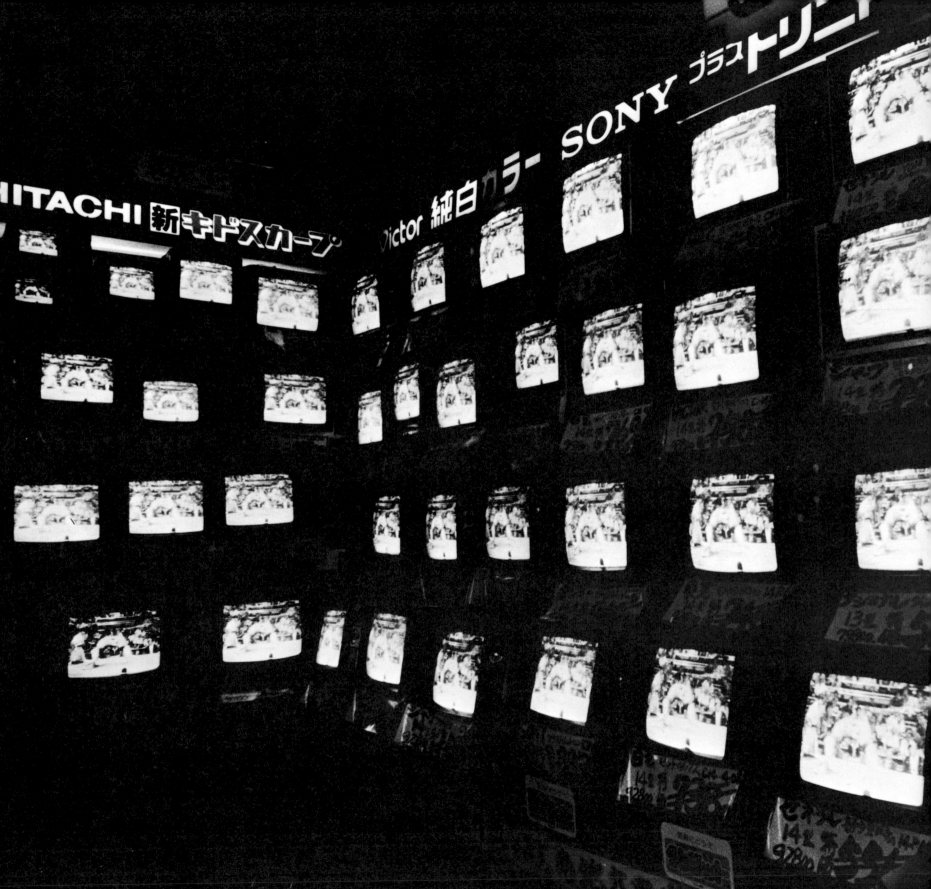

TODAY

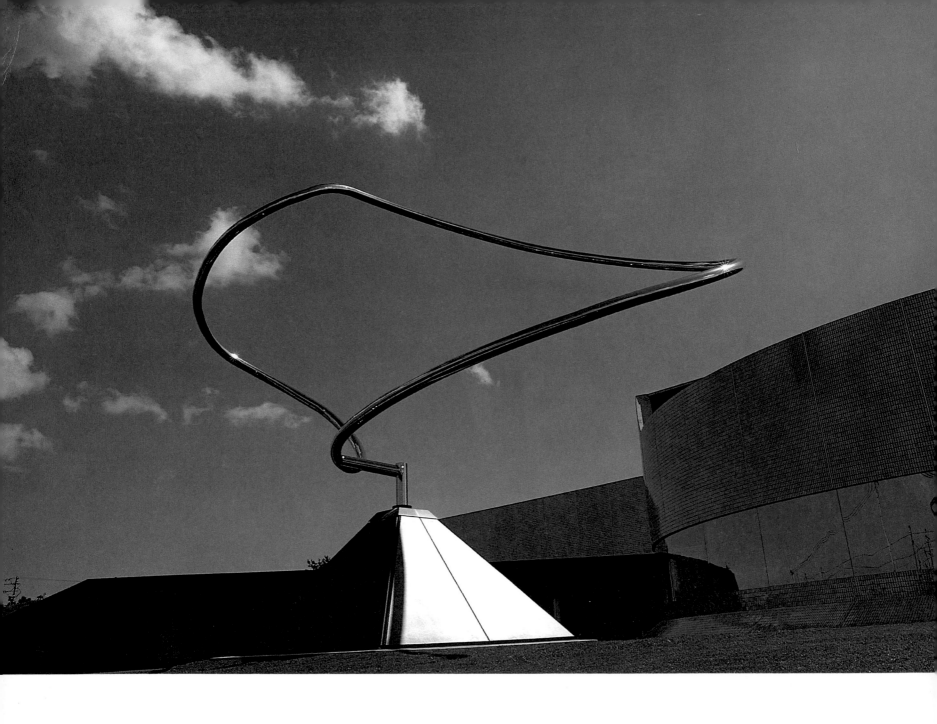

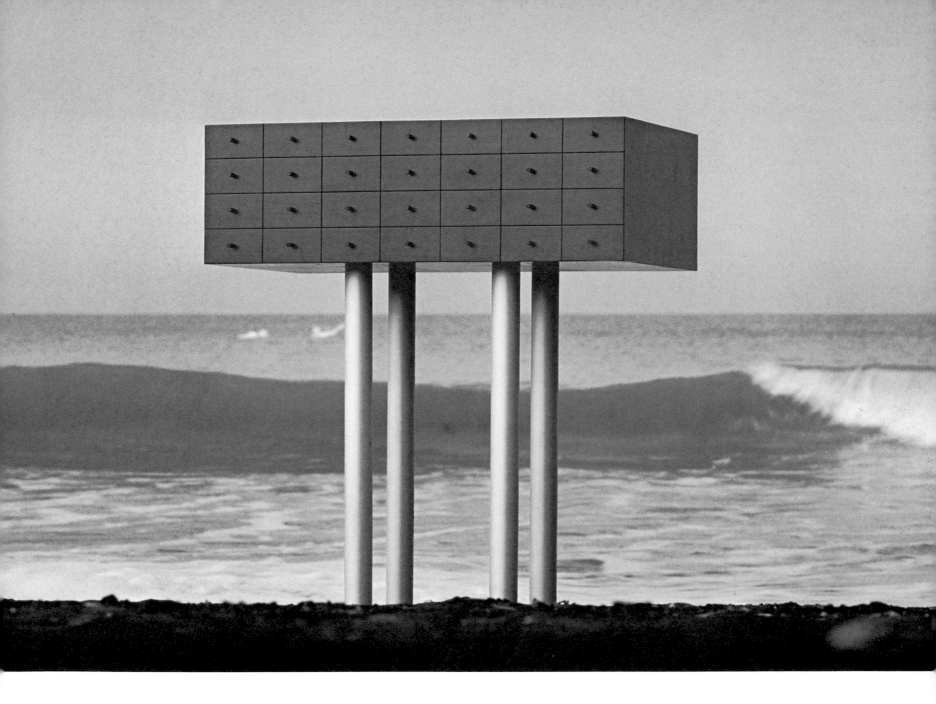

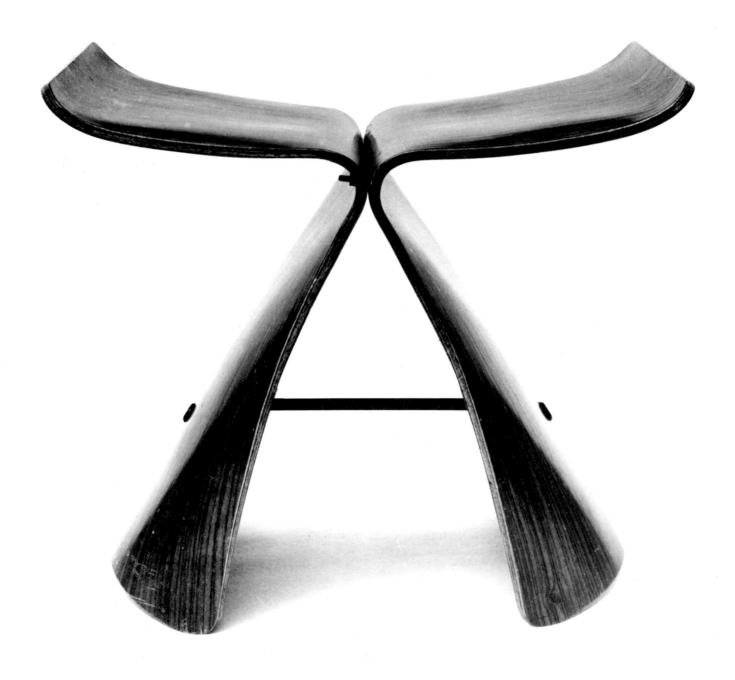

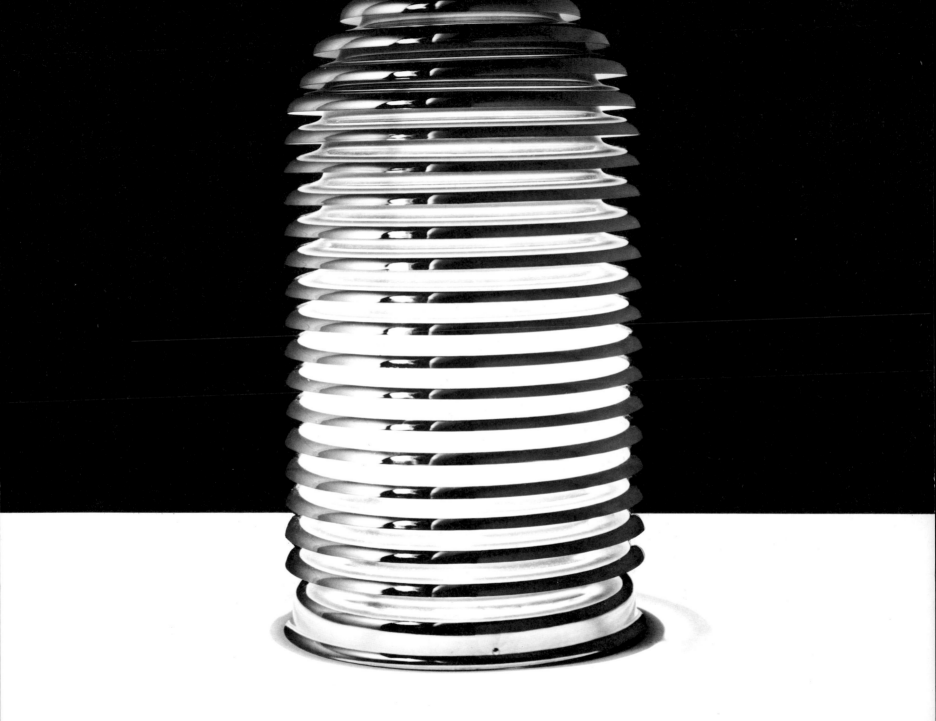

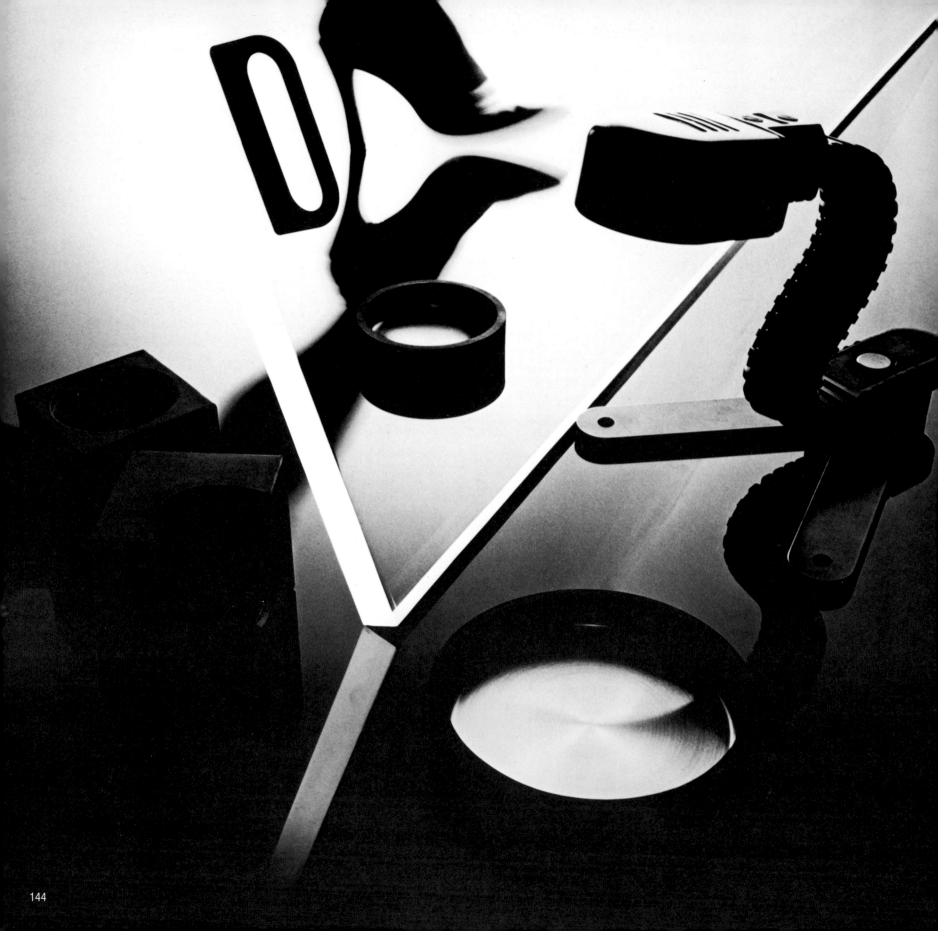

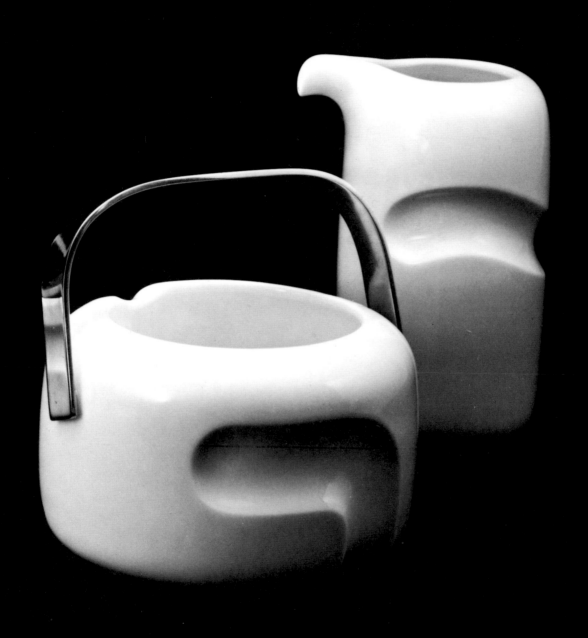

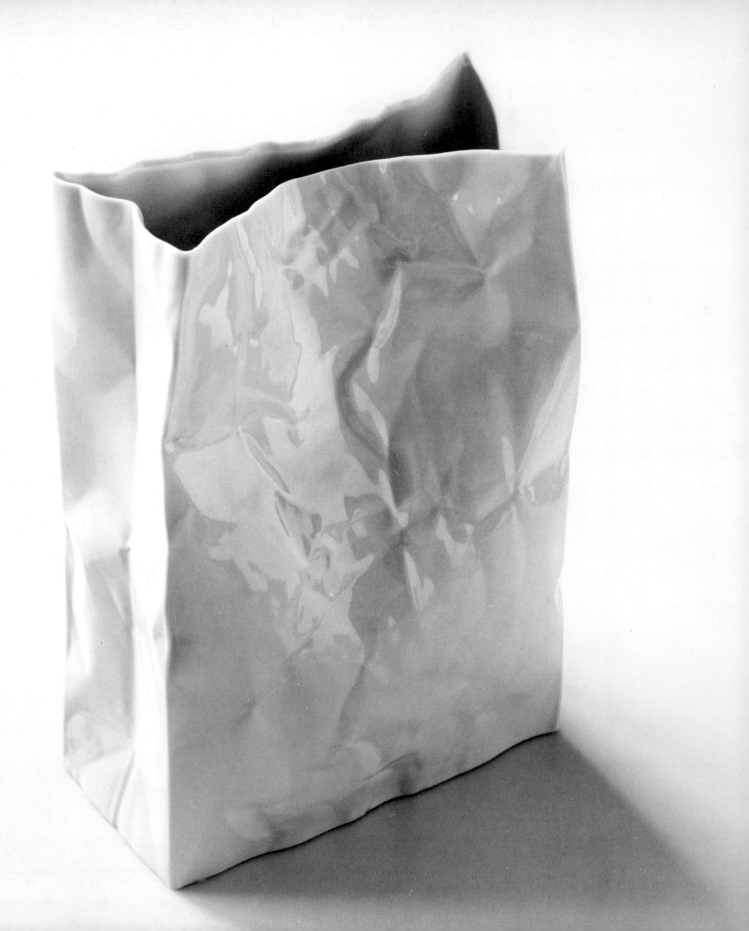

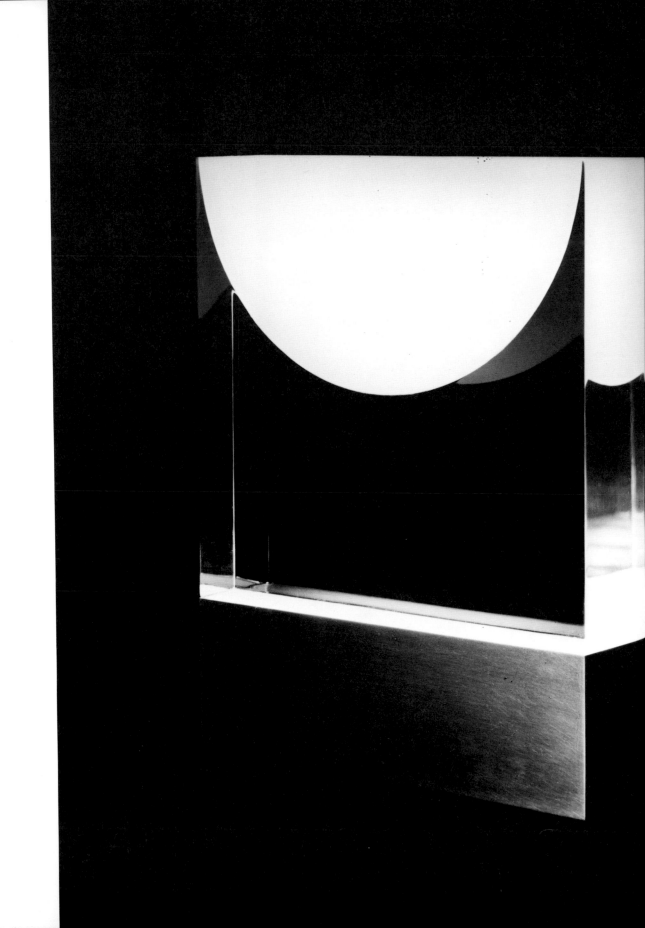

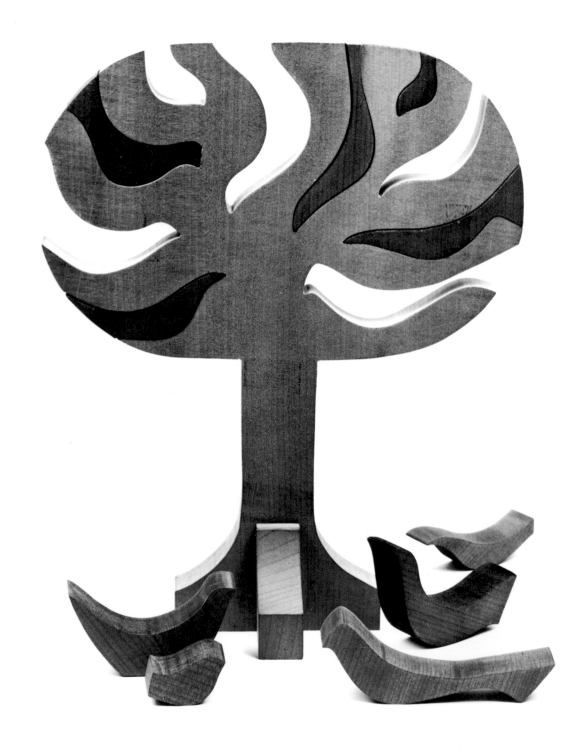

Captions

Cover. *Kumade*, decorative "rake" bought at the Otori Festival to ensure financial success for the coming year. Costume by Issey Miyake. (photo: Bishin Jūmonji).

pp. 34–35. Morning on the Japan Sea coast. (photo: Takeji Iwamiya)

pp. 36–37. *Ukiyo-e* print by Andō Hiroshige (1797–1858), "Suhara", the fortieth station, from "The Sixty-nine Stations on the Kisokaidō". Travellers seek shelter and bearers scurry from a sudden squall.

p. 38. Two beliefs—Buddhism and Shinto—exist together in Japan. On New Year's Eve, Buddhist temple bells ring out; on New Year's Day, people visit Shinto shrines.
 The *shimenawa* of the Izumo Grand Shrine, Shimane Prefecture. Such straw *shimenawa* mark off the most sacred parts of shrines. (photo: Yasuhiro Ishimoto)

p. 39. Hana-e ritual at Yakushi-ji temple, Nara. This ritual combines worship of the Buddha with a welcome to spring. (photo: Ken Domon)

p. 40. Cherry blossoms, the symbol of spring, at Kyoto's Tenryū-ji temple. (photo: Takeji Iwamiya)

p. 41. Autumn maples at Kongōrin-ji temple, Shiga Prefecture. (photo: Naomi Maki)

p. 42. Girls in kimono at a graduation party. Nowadays such bright attire is worn only on formal, celebratory occasions. (photo: Gorō Iwaoka)

p. 43. The naked festival held in winter at Kōnomiya shrine, Aichi Prefecture. Cold and bare bodies in energetic competition purge the year's evil from the men of this parish. (photo: Yoshimasa Watanabe)

p. 44. *Okame* mask. The *okame* figure is a complex of feminine beauty, humour, sex and folk religion. (photo: Takeji Iwamiya)

p. 46. Earthenware pot (*yukihira*) for making rice gruel. (photo: Takeji Iwamiya)

p. 47. Potter at work. (photo: Kidō Ushio)

p. 48. Rain cape (*mino*). Such capes made from reeds, rushes, grasses and straw were used by farmers, fishermen and mountain people. (photo: Takeji Iwamiya)

p. 49. Willow basketwork trunk. (photo: Takeji Iwamiya)

p. 50. Bamboo basket. Bamboo was one of the most important materials for making containers for everyday use. (photo: Yōichi Yamazaki)

p. 51. Bamboo fencing on top of a stone wall, Daitoku-ji temple, Kyoto. (photo: Takeji Iwamiya)

p. 52. Cedars cover the slopes of the hills north of Kyoto. The trunks are trimmed to prevent the formation of knots in the wood. (photo: Takeji Iwamiya)

p. 53. Wooden container for cooked rice. (photo: Takeji Iwamiya)

p. 54. Lacquer tray and service setting. (photo: Takeji Iwamiya)

p. 55. Applying gold decoration on lacquer, Aizu, Fukushima Prefecture. (photo: Hidekichi Kanekawa)

p. 56. Iron kettle for boiling water, from the Nambu area, Iwate Prefecture. (photo: Yōichi Yamazaki)

p. 57. Stone basin in the form of an old coin, Ryōan-ji temple, Kyoto. (photo: Takeji Iwamiya)

p. 58. Indigo-dyed cotton in *e-gasuri* technique (threads dyed prior to weaving). (photo: Kidō Ushio)

p. 59. Washing the resist paste from dyed silk textiles, Kanazawa, Ishikawa Prefecture. (photo: Kidō Ushio)

p. 60. Paper-cord decorations (*mizuhiki*) and envelopes used for formal gifts. (photo: Takeji Iwamiya)

p. 62. Lacquer inkstone box, gold decoration and inlay, by Ogata Kōrin (1658–1716), entitled "Yatsuhashi". The motifs on the box are drawn from an episode in the *Tales of Ise*, a 10th-century romance. (collection: Tokyo National Museum)

p. 63. Fan-painting, showing a scene from *The Tale of Genji*, 17th century.

pp. 64–65 top. Lacquer bowls with designs of pine (winter) and plum (spring). (photo: Kidō Ushio)

pp. 64–65 bottom. Lacquer tea-caddies with designs of willow (summer) and pampas grass, bush-clover and chrysanthemum (autumn). (photo: Kidō Ushio)

p. 66. Nō drama dance fan (*chūkei*). (photo: Ikkō Narahara)

(top left) Kōhei Sugiura. Peking Opera announcement.

(top right) Ikko Tanaka. Theatrical performance series.

(bottom left) Kiyoshi Awazu. Mano-Dharma-Concert.

(bottom right) Gan Hosoya. Morisawa Photosetting Company.

p. 122. Posters.
(top left) Yūsaku Kamekura. 9th Annual Tokyo International Lighting Design Competition.
(top right) Makoto Nakamura. Shiseidō perfume.
(bottom left) Mitsuo Katsui. 3rd Japan Industrial Design Conference.
(bottom right) Kazumasa Nagai. Seven New Design Powers.

p. 123. Posters.
(top left) Yoshio Hayakawa. "Faces in White" (announcement of his own exhibition).
(top centre) K² (Keisuke Nagatomo and Seitarō Kuroda). Theatre poster.
(top right) Yōsuke Kawamura. "Living in the Jungle Land".
(bottom left) Ryūichi Yamashiro. "Né Collage" (announcement of his own exhibition).
(bottom centre) Takahisa Kamijō. New Music Media concert.
(bottom right) Harumi Yamaguchi. Mann's Wines.

p. 124. Textile design by Hiroshi Awatsuji. (photo: Mitsumasa Fujitsuka)

p. 126. Screen-painting of a festival commemorating the warlord Toyotomi Hideyoshi, early 17th century. (collection: Tokugawa Reimeikai Foundation)

p. 127. The hero mounts an immense fire-breathing toad and displays his magic power. Scene from the *kabuki* play *Tenjiku Tokubei Ikoku Banashi*. (photo: Keizō Kaneko)

p. 128. Plastic toy masks, mainly of popular television cartoon figures, are seen at every festival. (photo: Taishi Hirokawa)

p. 129. Papier-mâché Daruma dolls. One eye is painted in when a wish is made, the other when the wish is fulfilled. (photo: Kidō Ushio)

p. 130. Bicycles parked near a suburban commuter train station. (photo: Haruo Tomiyama)

p. 131. Restaurants advertise their menus by displaying realistic plastic food models. (photo: Haruo Tomiyama)

p. 132. Illuminated signs bombard the senses in Japan's cities. (photo: Haruo Tomiyama)

p. 133. For the bored player of *pachinko*, Japan's version of pinball, some *pachinko* parlours installed mini-televisions in the centre of the machines. (photo: Taishi Hirokawa)

p. 134. Weekly magazines are the most widely read publications besides newspapers; the number of such weeklies is always on the increase. (photo: Haruo Tomiyama)

p. 135. Comic books have come to capture the time and money of a large part of the Japanese population. (cartoonist: Satoshi Ikezawa)

p. 136 top. Magazine advertisement for a black-and-white television set.
Art directors: Masaharu Higashizawa, Yōzō Nakamori
Photography: Bishin Jūmonji

p. 136 bottom. Poster for the film *L'Innocente*.
Art director: Eiko Ishioka
Photography: Kazumi Kurigami

p. 137. Photograph from a fashion magazine.
Art director: Katsumi Asaba
Photography: Eiichirō Sakata

p. 138. Display of television sets for sale. (photo: Haruo Tomiyama)

p. 140. Moving sculpture by Takamichi Itō. (photo: Yoshio Shiratori)

p. 141. "Solaris Drawers", chest designed by Shirō Kuramata. (photo: Mitsumasa Fujitsuka)

p. 142. Butterfly stool designed by Sōri Yanagi.

p. 143. "Saturno", lighting fixture designed by Kazuo Motozawa. (photo: Mitsumasa Fujitsuka)

p. 144. "Cobra", rubber desk lamp designed by Masayuki Kurokawa. (photo: Shinichirō Shishido)

p. 145. Porcelain water-pitcher and ice-bucket designed by Masahiro Mori.

p. 146. Porcelain vase designed by Makoto Komatsu. (photo: Mitsumasa Fujitsuka)

p. 147. "Edge Lamp", lighting fixture designed by Minami Tada. (photo: Shigeyoshi Nobori)

p. 148. "Bird Tree", wooden toy designed by Shigeo Fukuda.

Photo Credits:
p. 63. Kōrinsha Publishing Co.
p. 70. Bunka Publishing Bureau
p. 80. Kajima Institute Publishing Co.
p. 95. John Weatherhill, Inc.
p. 97. Wakabayashi Butsugu Seisakujo
p. 104. Sony Corporation
p. 105. Matsushita Electric Industrial Co.
p. 105. Sharp Corporation
p. 106. Canon Inc.
p. 110. Shochiku Co.
p. 135. Shūeisha Publishing Co.
p. 137. Fashion News

Note: Names of all pre-modern Japanese are given in Japanese order, surname first; those of all modern Japanese, in Western order.

Catalogue design:——Ken'ichi Samura
Editorial supervision:—Ikko Tanaka Design Studio
　　　　　　　　　　Kayoko Takagi
　　　　　　　　　　J. V. Earle
　　　　　　　　　　Machiko Moriyasu
Translation:————— J. V. Earle